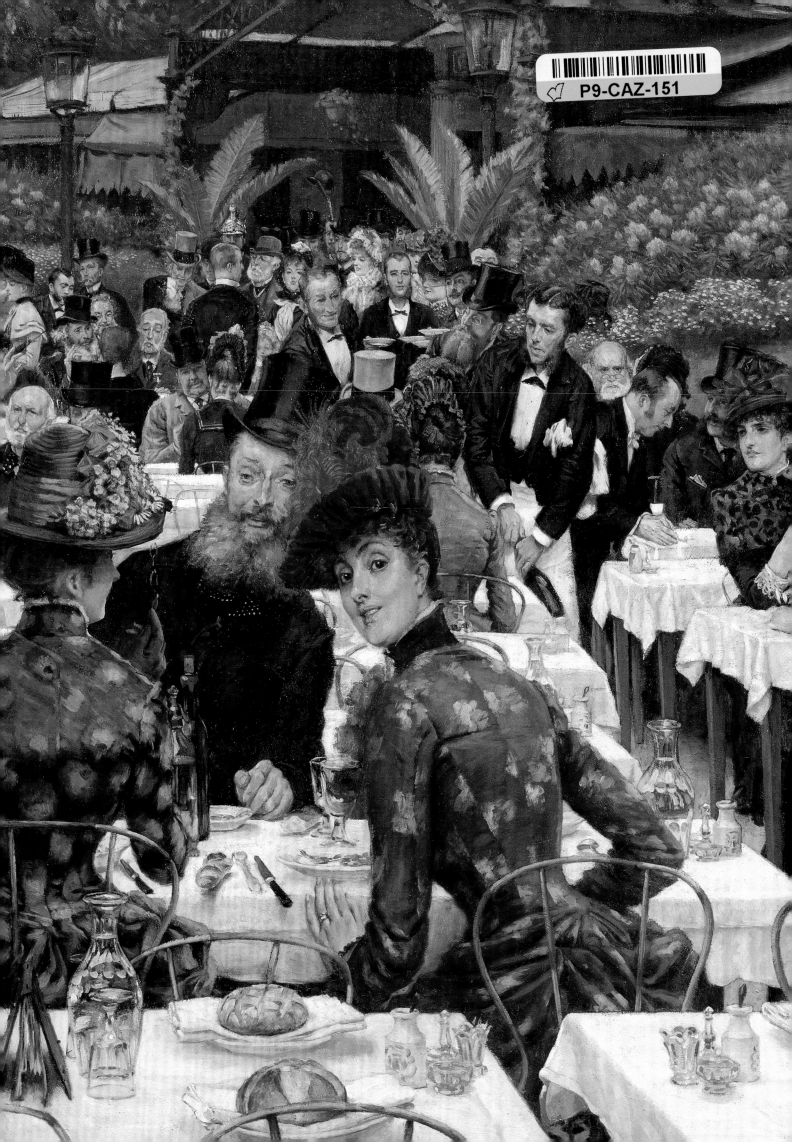

PARIS AND THE COUNTRYSIDE

Modern Life in Late-19th-Century France

PORTLAND MUSEUM OF ART

PORTLAND, MAINE

2006

The exhibition *Paris and the Countryside: Modern Life in Late-19th-Century France* and the accompanying catalogue are dedicated to the memory of John Goldkrand, M.D.

The Portland Museum of Art gratefully acknowledges Scott and Isabelle Black, whose leadership and support have made this exhibition possible.

This exhibition is generously sponsored by TD Banknorth. Media support is provided by WCSH 6 and the Portland Press Herald/Maine Sunday Telegram.

Contents

SPONSOR'S STATEMENT vii

DIRECTOR'S FOREWORD ix

ACKNOWLEDGMENTS xi

Curator's Statement
Carrie Haslett xiii

The Urban Mirror:
Contrasts in the Vision of Existence in the Modern City
Gabriel P. Weisberg 1

French Landscape Painting and Modern Life
Jennifer L. Shaw 63

EXHIBITION CHECKLIST 117

LENDERS TO THE EXHIBITION 133

PHOTOGRAPHY CREDITS 135

Sponsor's Statement

Nearly four years have elapsed since the last French painting retrospective at the Portland Museum of Art. During this interval the Museum's Director, Dan O'Leary, and I discussed various alternatives for a meaningful exhibition ranging from an all Toulouse-Lautrec show to one on Dada and Surrealism. Upon careful deliberation, Dan and his curatorial staff opted for a focus on French modernism. Appropriately, this summer's presentation is entitled *Paris and the Countryside: Modern Life in Late-19th-Century France*.

From the time of Louis XIV until the mid-nineteenth century, French painting had been dominated by two main themes, the depiction of mythological figures and history paintings. Two examples from the Musée d'Orsay, in Paris, underscore this proclivity, Alexandre Cabanel's *Birth of Venus* (1863) and Thomas Couture's *The Romans of the Decadence* (1847). Nevertheless, in the middle of the nineteenth century, a confluence of factors ushered in the age of modernism: 1) the onset of the industrial revolution with the concomitant development of the railway network throughout France; 2) the intellectual ferment of writers like Charles Baudelaire and Stéphane Mallarmé; and 3) the reaction to the destruction of the Paris Commune in 1870 during the Franco-Prussian War.

Most art historians cite Édouard Manet's *Le Déjeuner sur l'herbe* (1863) as the inception point for modernism. Herein, Manet negated Giorgione's great work, *Concert Champêtre*, by injecting a garish nude into the idyllic landscape. Quite candidly, Manet's iconoclasm was an anomaly. Born into a bourgeois family and every bit a flâneur, he gravitated toward the intellectual elite at the Café Guerbois. Others credit Gustave Courbet's two nonhierarchical paintings, *A Burial at Ornans* (1849) and *The Painter's Studio; A Real Allegory* (1855), as the demarcation line for modernism. In these two examples, Courbet painted himself, clergy, musicians, townsfolk, and children with equal weight and along a common picture plane.

While Baudelaire may have defined modernism in his essay "The Painter of Modern Life," I believe that modernism was shaped by two radical changes.

First, painting moved from a narrative subject to contemporaneous events of everyday people. Equally important, the method by which the artist applied paint to the canvas was novel. Commencing with the Impressionists, artists no longer rendered a fixed image of a person or a landscape but rather a fleeting sensation of the subject. Parisian streets, dance halls, sailboats, race courses, railway bridges, and the countryside all became candidates for the Impressionists' comma brushwork.

As the second half of the nineteenth century progressed, Impressionism branched into three disparate directions. Desiring to "make something more solid than Impressionism," Paul Cézanne developed constructionism, introduced asymmetric vanishing points, and created still lifes with trompe l'oeil. In the mid-1880s Georges Seurat with his Neo-Impressionism moved toward abstraction and multiple vanishing points. Finally, Paul Gauguin and his disciples at Pont-Aven flattened the picture plane and introduced Symbolism with large monochromes of primary colors. I am pleased to relate that this summer's exhibition encompasses the full spectrum of modernism with many excellent paintings, from Manet's *Children in the Tuileries Gardens* (circa 1861–62) through Henri Matisse's proto-Fauve *Le Pont St. Michel* (circa 1901).

It is with great pleasure that my wife, Isabelle, and I sponsor this wonderful exhibition. We dedicate this retrospective to the memory of our cousin, Dr. John Goldkrand, who passed away unexpectedly on December 31, 2005. John spent part of his childhood in Portland, excelled at Bowdoin College, and enjoyed every summer with his beloved wife A.M. at his Harpswell home. Over the past decade they enthusiastically attended each summer show at the Portland Museum of Art. Johnny liked French painting and, even more, good French wine.

—Scott M. Black
March 26, 2006

Director's Foreword

THE PORTLAND MUSEUM OF ART is extremely fortunate to present *Paris and the Countryside: Modern Life in Late-19th-Century France*, an exhibition that celebrates the diversity and excitement of late-nineteenth-century French art. Since the early 1990s, the Museum has regularly explored this dynamic era, which continues to inspire and captivate viewers of all ages and levels of art historical knowledge.

We would not be able to mount this exhibition that carefully explores the dual notions of modernity and modernism without the generous support of Scott and Isabelle Black, whose collection has provided core works around which the exhibition has been developed. We are also deeply indebted to Scott and Isabelle for their established tradition of generous financial support and commitment to French art. Their thoughtful decision to fund this exhibition in memory of Dr. John Goldkrand allows us to honor an individual who loved Maine and who encouraged all our efforts to bring outstanding exhibitions to the people of this state.

Also essential to this exhibition are significant loans from additional dedicated collectors, whose magnificent paintings—whether by van Gogh, Degas, Monet, Béraud, or Abbéma—are sure to delight. We are sincerely grateful to all of these private partners, as well as to an array of public institutions.

—DANIEL O'LEARY
Director

Acknowledgments

WE ARE MOST GRATEFUL to the many institutions and individuals who have lent so generously to this exhibition. I would especially like to thank Scott and Isabelle Black, whose support has made this show possible.

I would like to acknowledge the following individuals and organizations for a wide array of support: Cathleen Anderson, Zimmerli Art Museum; Kylee Denning, The Haggin Museum; Michelle Facos, Indiana University; Aprile Gallant, Alona Horn, and Jessica Nicoll, Smith College Museum of Art; Wendy Kaplan, Los Angeles County Museum of Art; Jeannine O'Grody, Birmingham Museum of Art; John W. Payson; George Shackelford, Museum of Fine Arts, Boston; Kenneth Wayne, Heckscher Museum of Art; and Wildenstein & Co., Inc.

My gratitude as well to each of the essayists for their insightful texts and willingness to tackle such complex topics. Thanks to Fronia W. Simpson, a remarkable editor, and to David Skolkin, whose creative catalogue design vividly brings to life the themes of the exhibition.

At the Museum I have many colleagues to thank, notably Dan O'Leary, Susan Danly, Jessica Routhier, Ellie Vuilleumier, Stephanie Doben, Stuart Hunter, Gregory Welch, Kris Kenow, Karin Lundgren, Kristen Levesque, Kathy Bouchard, and Jada Clement. Also very much appreciated are the research and expertise of Dr. Eric Hirshler, Jessica Hollander, and Arlene Palmer Schwind.

—CARRIE HASLETT
Joan Whitney Payson Curator

Curator's Statement

Carrie Haslett

IN RECENT HISTORY THE PORTLAND MUSEUM OF ART has organized a large-scale European exhibition every other summer. This schedule meant that on the heels of the last such exhibition, *European Muses, American Masters: 1870–1950*, we were already developing an idea for the next project. Because of the time period covered by the *Muses* show, I was able to think about the rise of modernism and how it played out in art on both sides of the Atlantic. In considering several generations of Americans who went to France and the lifestyles they pursued there, as opposed to what was possible in the United States, I was repeatedly reminded that at the time France offered not only new approaches to art but also distinct attitudes about modern life.

Charles Baudelaire's call for artists to "paint modern life" is a truism in art historical accounts of the development of French Impressionism. This exhibition and its catalogue focus on what was modern about life in France during the second half of the nineteenth century (modernity) and suggest the variety of ways that artists depicted it (modernism). In drawing together a wide range of images that speak to both concepts, I hope to re-create in the galleries a sense of the truly radical nature of the art of this period. In this catalogue, two authors explore more fully the meaning and reach of these artworks.

In first considering the topic of modernity, I compiled a list of works located far and wide, a number of which are simply not within the reach of a regional museum (Édouard Manet's *A Bar at the Folies-Bergère*, Georges Seurat's *A Sunday on La Grande Jatte*, for example). With the help of colleagues I moved beyond well-known choices and made many worthwhile discoveries that collectively point to an array of interesting facets of modern society, as well as the many directions modern art took during the era. In particular, I divided the works of art to be exhibited into two broad realms—those set within the city (namely Paris) and those outside it.

I knew that a seasoned scholar was required to tackle the complex topic of modern life in Paris during the late nineteenth century in France, so I was delighted that Gabriel Weisberg agreed to contribute an essay. Weisberg's epic

understanding of all things Parisian at this time allowed him to craft a far-reaching essay that touches on a marvelously wide range of topics that together capture, from a distinctly human viewpoint, something of the richness of life in the evolving capital. Using the objects secured for the exhibition, Weisberg discusses aspects of urban modernity that diversely affected rich and poor; created opportunities for women as artists, tastemakers, and consumers; spawned and/or sustained an array of performing arts, both highbrow and popular; and embraced the influx of non-French culture.

In her most insightful essay, Jennifer L. Shaw offers a thorough overview of the rise of modernism in French landscape painting as it paralleled the desire of artists to demonstrate, through their techniques and often their choice of subjects, that they belonged to a new era of picture making. Her thought-provoking interpretations of the wide range of landscape paintings in the exhibition bring to life the surprisingly many faces of the French countryside, only fairly recently connected to Paris by train, including travel and leisure, industry and pollution, and artists' colonies and retreats.

It is hoped that the scope and direction of this exhibition and its catalogue inspire viewers and readers to approximate the vitality of the era as it was experienced by artists and viewers at the time, and in so doing perhaps shed new light on a body of work that has become seemingly all too familiar.

The Museum is proud that this exhibition honors the life of John Goldkrand, M.D., who surely would have delighted in this celebration of human vitality.

Paris and the Countryside

Modern Life in Late-19th-Century France

The Urban Mirror:
Contrasts in the Vision of Existence
in the Modern City

Gabriel P. Weisberg

I

THE URBAN SETTING

When Maurice Biais designed a poster for the opening of La Maison Moderne
in 1900, he carefully revealed a series of contradictions in his image (Fig. 1).
The well-dressed woman eyeing the objects on display in Julius Meier-Graefe's
elegant new shop-*cum*-art gallery was none other than the well-known
Montmartrian performer Jane Avril. While many knew her as a dancer from
the Moulin Rouge, few realized that Avril was an
artist, not solely a performer, and that her lover,
Maurice Biais, had selected her for his poster to
call attention to the way in which women, and
artists, were seen as purveyors of visual urban cul-
ture. Avril's interest in the visual arts evolved both
from her innate artistic sense, heightened by her
efforts to find a suitable creative voice, and her
connections to the performing world of
Montmartre, which included many young artists,
among them Henri de Toulouse-Lautrec. The
selection of Jane Avril also reflected a fundamental
shift in attitudes toward women: she embodied the
"new woman."[1] Avril's ability to perform, and her
eventual insistence on increasing independence as
a performer, reflected the ways in which women
from a certain stratum of society, in this case the
world of urban entertainment, were able to escape
women's otherwise voiceless position to enter a
world controlled by men. Whether the freedom
afforded this segment of womankind carried over
to women in general is debatable, but it is clear that
the more tolerant world of entertainment allowed
certain women to claim freedom of action.

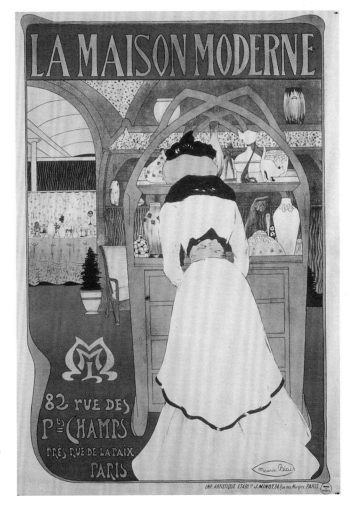

1. MAURICE BIAIS

La Maison moderne, circa 1900

Lithograph on paper
44¾ × 30

Musée de la Publicité, Paris

In reality, Biais's poster signified that the urban art gallery held a special place in the urban fabric, becoming the focus of much visual excitement. It was the locale where painters and designers could exhibit their works, and it was also there that new connoisseurs and collectors could build the modern home by acquiring objects that would change their surroundings.[2] Recently opened galleries were able to reach the independent collector, thus offering men, but especially women, the possibility of participating in a revolution of the senses that would result in an urban scene that was less crude and coarse and allow more subtle tastes to emerge. It was the independent woman, as much as men, who brought about this aesthetic revolution.

Although Biais was never again to produce such a topically rich image, other artists following his lead showed ways in which the Parisian art scene had been enhanced. Manuel Robbe, another of the leading turn-of-the-century printmakers, for example (Fig. 2), demonstrated that investing in the new culture of fashion was one way to redefine class hierarchies. In print after print, Robbe drew attention to the fashionable woman, to the places she visited, to the fact that she was part of the fin de siècle artistic and social scene. Other artists were engaged by the vision of woman as a creator. Alfred Stevens, for example, depicted Sarah Bernhardt as a painter, attesting to the fact that she had been trained, albeit briefly, at the Académie Julian. Stevens shows her as a fashionable artist in a studio filled with her own work and a Corot-like landscape on her easel (see Fig. 59). She was the image of both a highly successful visual artist and a woman who had become a force in several creative fields. Her lifestyle attracted other women, one of whom was Louise Abbéma. Abbéma, briefly Bernhardt's lover, was a painter who indulged her passion for seaside entertainment by completing a picture of a game of croquet (see Fig. 56).

In creating these images and in exhibiting them in public, artists contributed to the emergence of a new vision of the urban scene, one more receptive to all the nuances and the contrasts in society. However, a multifaceted vision revealed the contrasts between those who had the means to indulge in the new aesthetics and those who remained mired in poverty. While many of the prints and paintings created at the end of the nineteenth century reflect an atmosphere of

2. MANUEL ROBBE

La Visiteuse (*The Visitor*), undated

Aquatint on paper
image: 8⅛ × 5⅞
sheet: 12 × 8⅝

Fine Arts Museums of San Francisco, Achenbach Foundation for Graphic Arts, 1963.30.11479

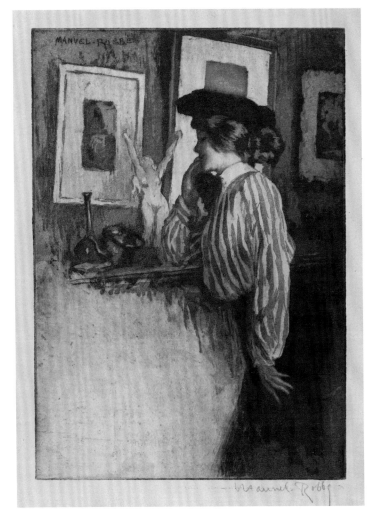

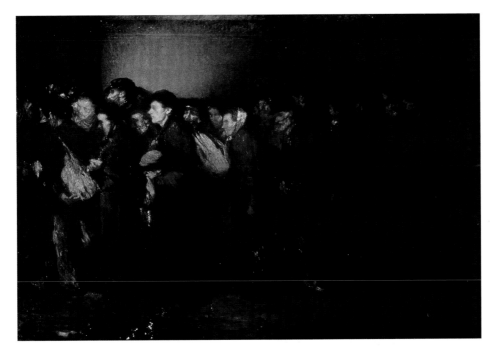

3. JULES ADLER

The Soup Kitchen, 1906

Oil on canvas
86⅞ × 138⅝

Petit Palais, Paris

wealth and the importance of new money in cultivating tastes that were up-to-the-minute, others bear witness to a less salubrious side of urban existence. The development of new working methods and the advent of more mechanized production systems, in addition to the influx of rural laborers into the city, put many individuals out of work and led to intense rural depopulation. Artists such as Jules Adler responded to the necessity of feeding the poor by painting images of street soup kitchens (Fig. 3). There were also numerous images, drawings as well as paintings, that depicted the poor living in the no-man's-land encircling cities.[3] Such visualizations of down-and-out urban life were often dour and depressing. For all of those able to enjoy fashion and entertainment there were many others who struggled to survive. It is to these two poles of city life that we must now proceed in order to have a fuller grasp of the ways in which artists responded to all the facets of urban existence by 1900 and beyond.

THE DENIZENS OF THE STREET

As one of the new coterie of artists involved with changing the visible perceptions of the urban environment, Edgar Chahine drew on his observations of both popular culture and the numerous social types that he witnessed in the cabarets, brothels, and streets of Paris. A transplanted Armenian aware of social exigencies and the pressures that affected people trying to survive, Chahine designed lithographs of the poor, of jobless workers who prowled the streets in hunger. He spared no mercy when chronicling "street people," those who had been left behind by the changing urban environment. Chahine lived in Montmartre, a section of the city more open to, and more accepting of, social outcasts, artists, and the poor alike. There he saw the ramshackle abodes

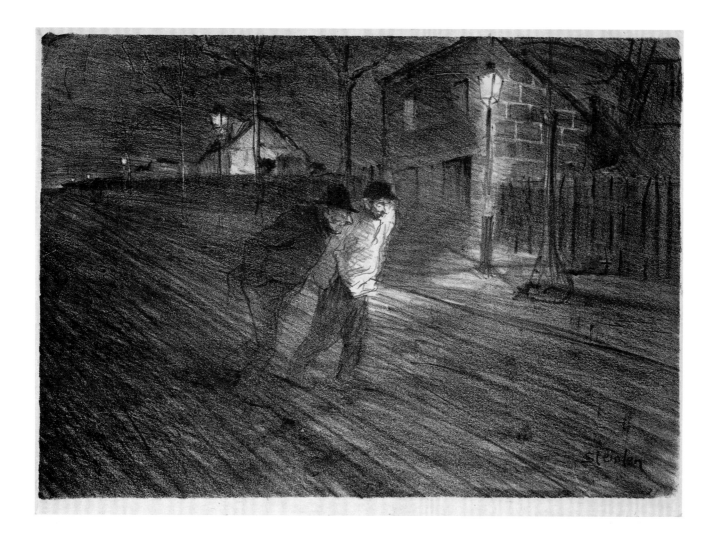

4. THÉOPHILE-ALEXANDRE STEINLEN

Rue Caulaincourt, undated

Lithograph on paper
image: 10 × 14
sheet: 11 × 14½

Fine Arts Museums of San Francisco, Achenbach Foundation for Graphic Arts, 1963.30.33785

of the poor, where they bonded with other destitute vagrants out of necessity.[4] Chahine's works (his pastels and lithographs have survived, whereas his paintings have not) reflect the influence of Théophile Steinlen, the avowed supporter of the poor and the homeless, whose print of rue Caulaincourt became a well-known icon of the era (Fig. 4). Here two beggars, men clearly out of work, are walking against a stiff wind on a cold, wintry night; they are isolated, hungry, down on their luck. The surroundings look forbidding, and the inclement weather reinforces the mood of despair. Both Chahine and Steinlen, in paintings and prints depicting the ragged life of the poor on the Butte of Montmartre (and other similarly less fortunate sections of Paris), underscored the seedier side of life, the fundamental social ills that society at large was not addressing. This display of public tragedy prompted many artists, such as Chahine, Paul Blanc, and Pablo Picasso, to chronicle and thus, perhaps, increase the concern for the city's beggar population through widely circulated images.[5] The number of men, women, children, even whole families, who could be seen begging increased to the extent that begging was restricted to city streets. In addressing these concerns and revealing a side of urban life difficult to avoid since it was visible on the streets of the city itself, printmakers, as well

as some painters, provided a degree of social consciousness that was desperately needed.

However, often the same artists portrayed a different aspect of city life. They became fascinated by the many entertainments offered in the city. Among these activities were wrestling matches (both men and women wrestled) whose bouts took place in the middle of a street or in a square, where they attracted crowds of onlookers who often bet on the outcome (Fig. 5). By recording such examples of popular entertainment, Chahine contributed to the memorialization of the life of the proletariat. In another print, against a background of ramshackle buildings and belching factory chimneys, Chahine once again revealed his sharp eye for street entertainment: the tightrope walker or acrobat. These figures, probably performers in a traveling circus, practiced in the streets, providing a diversion from the more pressing, and often difficult, demands of daily life. In both instances, Chahine, similar to Honoré Daumier before him, was sensitive to an aspect of urban life that reflected the mundane pleasures of the poor and the workers.

Another ubiquitous type in the life of the city was the ballerina, a figure that artists such as Edgar Degas, Jean-Louis Forain, and Louis Legrand depicted frequently, either singly or in groups during their classes. Whether the dance milieu can be viewed as a place conducive to illicit activities such as prostitution is debatable; not all young ballerinas were destined to end as harlots. However, it is certain that the manner in which the subject was treated by Degas, and especially Legrand, leads one to believe that the dance lesson, and particularly the *première leçon*, implied the possibility of sexual liaisons, and that ballet classes were a place where prostitution might flourish, with its combination of available young girls, often poor and ready to succumb to the temptation to be able to continue their training.[6] The paintings, prints, and pastels by Degas and Legrand became well known. The two artists portrayed young girls often shown in languorous poses, stretching their limbs, often in the company of unsavory older men suggestive of pimps or of those lecherous beings simply obsessed by the presence of young children. This is the case with Forain's *Behind the Scenes* (Fig. 6), where an older man, of obvious wealth, stands behind a young ballerina he is trying to seduce. The notion of implied sexuality that runs through some of Legrand's images,

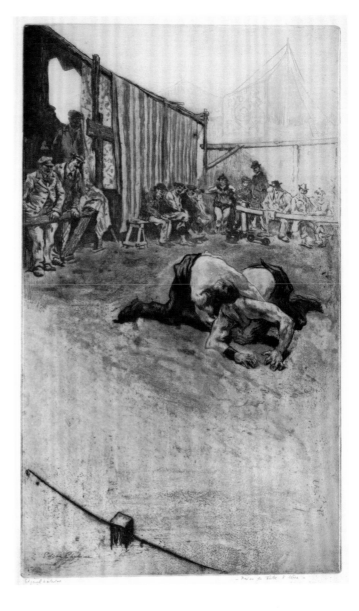

5. EDGAR CHAHINE

Wrestlers, 1904

Etching on paper
22¼ × 14¹⁄₁₆

Jane Voorhees Zimmerli
Art Museum, Rutgers, The
State University of New Jersey,
David A. and Mildred H. Morse
Art Acquisition Fund, 82.68.15

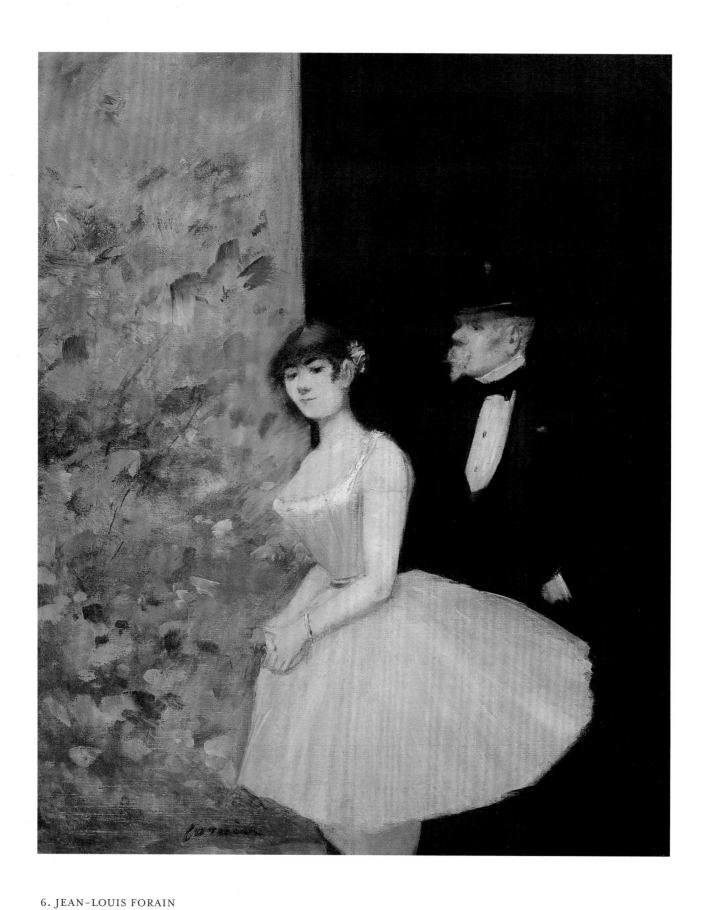

6. JEAN-LOUIS FORAIN

Behind the Scenes, circa 1880

Oil on canvas, 18¼ × 15⅛

National Gallery of Art, Washington,
Rosenwald Collection, 1943.11.4

including a painting (as well as a print) of a rape, reinforces the notion that Legrand's images have a larger social context than simply referencing activities linked to ballet classes.[7] He was among the first to open up the discourse about changing sexual mores in the urban scene with images that dramatically challenge preconceived notions. His *Au bar* (Fig. 7) addressed other themes: child prostitution, libertinism, and the presence of sexuality in the bars and cabarets of Montmartre. Legrand depicts a relationship that suggests multiple sexual interpretations. The dress of the woman and the intimate discussion with her companion strike a suggestive note, indicating that changes in sexual mores were more often found in those sections of the city frequented by artists and writers than in more temperate zones of the city, where the upper-middle class lived.

Changing sexual mores also attracted Vincent van Gogh. In a study of a barmaid that he may have completed in Antwerp and brought with him to Paris (Fig. 8), the painter has focused on a woman who worked as a waitress as well as a prostitute

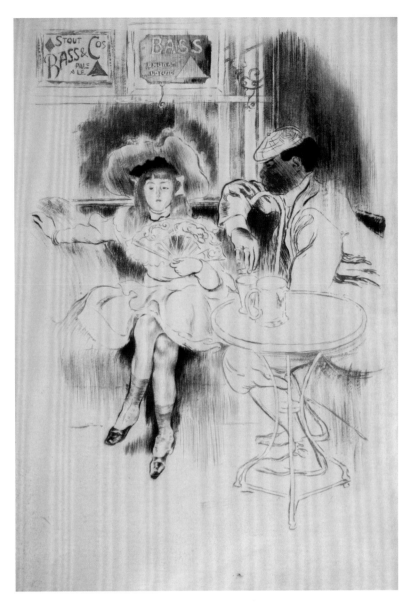

7. LOUIS-AUGUSTE-MATHIEU LEGRAND

Au bar, 1908

Etching and drypoint on paper
17 ½ × 12 ¼

Jane Voorhees Zimmerli Art Museum, Rutgers, The State University of New Jersey, Gift of Reece and Marilyn Arnold Palley, 1991.0441.002

when the opportunity or the need arose. Completing a series of portrait heads of the denizens and habitués of the cafés, van Gogh foreshadowed in this portrait other works he would make in Paris, and especially Montmartre. There he found it easier than in the Low Countries to form liaisons with café singers, barmaids, or prostitutes. Van Gogh joined many others in exploring this open territory in works that displayed a vigorous style that paralleled the freedom from societal constraints this new milieu offered.

Eugène Grasset, one of the primary printmakers of the color revolution, was also involved in topical themes during the 1890s. Sensitive to issues of addiction, especially caused by the concern over the drinking of absinthe, Grasset was equally aware of the increasing use of drugs as stimulants. In his *Morphine Addict* (Fig. 9), he centers attention on a young girl seemingly intent on achieving her needed fix; in this way, not only does his print speak to an increasing social issue of the urban environment in late-nineteenth-century Paris, but it also prefigures the drug addictions of today.

THE LAUNDRESS: A MODERN BEAST OF BURDEN

Ever since Émile Zola's novel *L'Assommoir* was published in 1877, attention had been riveted on one central iconic figure, the laundress, who came to symbolize the plight of the poor, overworked lower classes.[8] The laundress—and her companion in misery, the ironess—going about her activities from day to day, carrying heavy bundles of clothes through the streets of Paris or working, mired in an urban sweatshop, provided the visual personification of poverty for many artists. They saw the laundress as an oppressed beast of burden, as a figure whose manual labor was always strenuous, even demeaning, since her task was to wash the dirt out of the garments of others, but whose ability to survive was never questioned.

This extremely popular theme attracted painters such as Degas and numerous printmakers during the 1890s. Degas poignantly captures the dehumanization and anonymity of such workers in *The Laundress Ironing* (Fig. 10), a painting in which the identity of the woman is literally masked, both by what one imagines to be her forever-downturned gaze and by the very laundry on which she has worked. The artist's dual emphasis on laundry and the ironer's exposed arms masterfully reduces this woman to little more than her occupation.

Few artists at the turn of the century were as obsessed with the theme of the laundress as Théophile Steinlen. In a close-up view of women lugging their burdens, he recalled the earlier images of Honoré Daumier, in which laundresses, often accompanied by young children, hoisted their baskets of clothes (Fig. 11).[9] The artists demonstrated the continuum of the theme, as nothing had changed for the urban family or worker.[10] The fact that the figure of the laundress remained current in the artistic production of the nineteenth century, and even beyond, attests to its importance as a symbol of life's struggle during the era.

Steinlen used the laundress as a symbolic icon for the sense of oppression affecting all of the urban working class. Chained to a menial task simply to survive, they had little chance to improve their lot. By repeating this motif often, and under different guises, Steinlen was able to convey the never-changing truth of the urban condition: the working class was oppressed, tired, and overburdened. Steinlen was one of the principal advocates for an "art populaire," and his art often veered toward propaganda, as the message inherent in the figure of the laundress could not be lost on anyone aware of the social exigencies of Paris.[11]

No matter the theme, there were now artists eager to demonstrate that anything in the city was fair game for visualization. The fact that the city was often changing, that there were so many different crosscurrents being exploited at the same moment, also helps enlarge the spectacle for interpretation. This is certainly the way in which artists thought about the performers and the milieux of the cabarets and café-concerts.

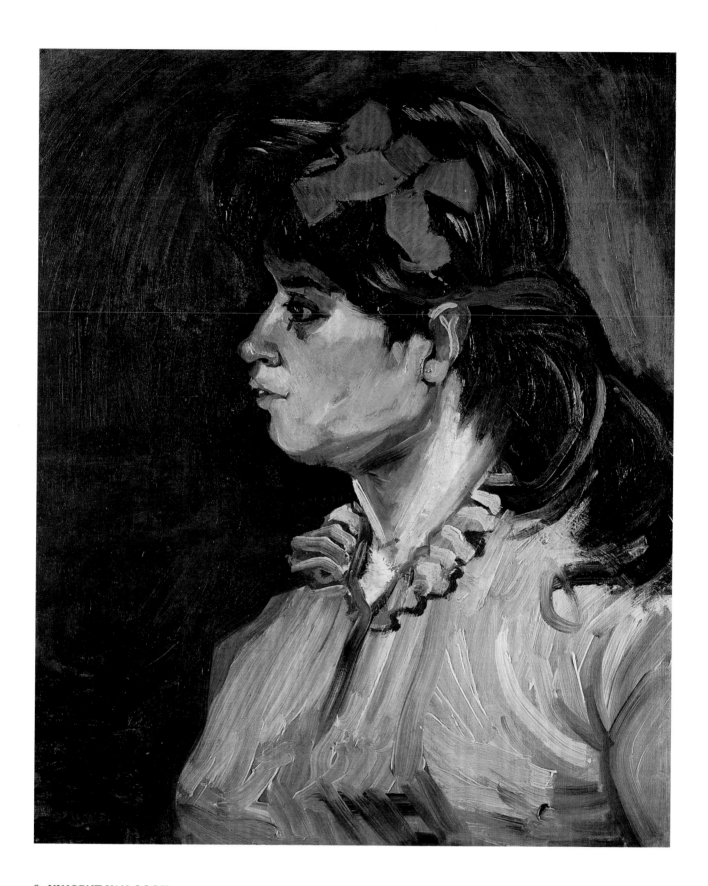

8. VINCENT VAN GOGH

Jeune Fille au ruban rouge (Young Woman with Red Bow), second half December 1885

Oil on canvas, 23⅝ × 19¾

Private collection

9. EUGÈNE-SAMUEL GRASSET

Morphine Addict, 1897

Lithograph on paper, 29½ × 23 7⁄16

Jane Voorhees Zimmerli Art Museum,
Rutgers, The State University of New Jersey,
Friends Purchase Fund, 77.054.001

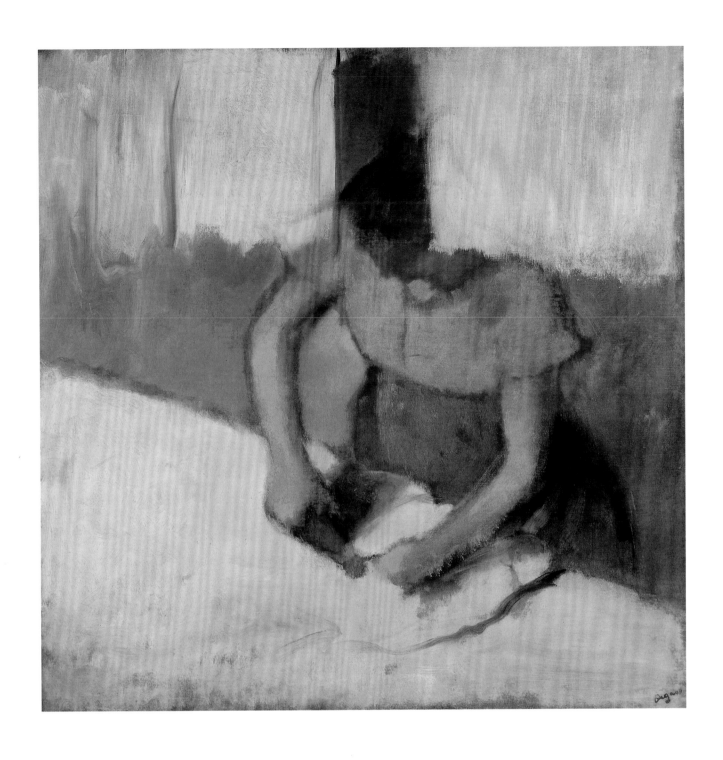

10. EDGAR DEGAS

La Blanchisseuse repassant (*The Laundress Ironing*),
circa 1882–86

Oil on canvas, 25½ × 26¼

Courtesy of the Reading Public Museum,
Reading, Pennsylvania

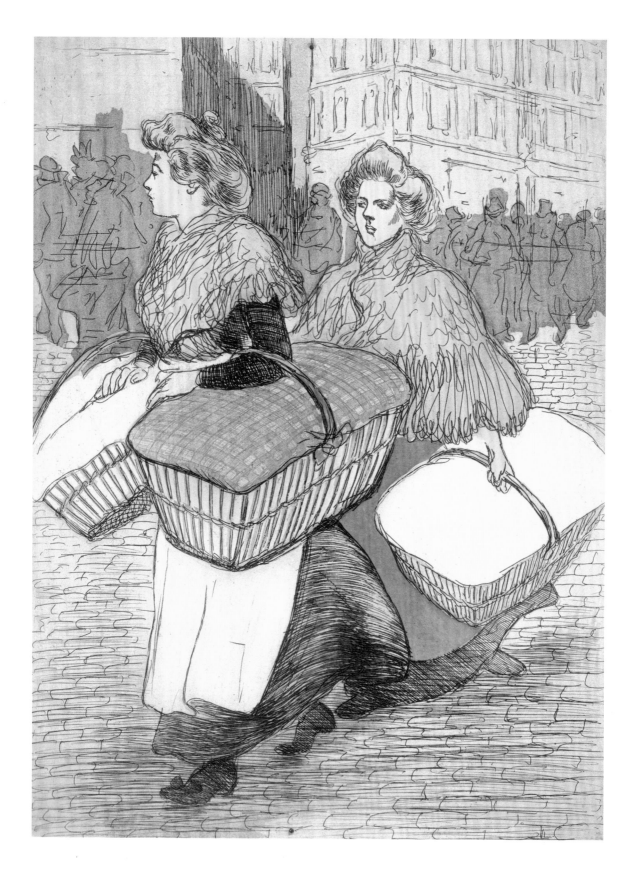

11. THÉOPHILE-ALEXANDRE STEINLEN

Les Blanchisseuses reportant l'ouvrage
(*Washerwomen Carrying Back Their Work*), 1898

etching and aquatint printed in five colors
on heavy white wove paper, plate: 14½ × 10⅝
sheet: 19¹³⁄₁₆ × 12¹³⁄₁₆

Smith College Museum of Art, Northampton, Massachusetts,
Gift of Selma Erving, class of 1927, SC 1976: 18-68

Life in Paris had greatly changed after the disaster of the Franco-Prussian War and the destruction of a good part of the city during the Commune (1870–71). While Paris was being rebuilt, an elaborate café and restaurant scene developed, suggesting that nightlife was central to the revitalization of the city; some of these sites were filled with wealthy patrons eager to be seen.[12] Artists as diverse as James Tissot and Jean Béraud devised elaborate compositions picturing the new locales where people went to be seen (Fig. 12). While fashionable restaurants attracted the social elite, there were far smaller establishments, essentially those located in Montmartre, that became havens for creative artists, the bohemian underground, and artists who wanted to escape confining social attitudes. Among the best known was the Chat Noir cabaret, where artists indulged in innovative performances, exhibited their works, and established an aura of intense creativity crucial for the nurturing of new ideas. Other cabarets attracted a fashionable clientele, including Les Quatr'z Arts (Fig. 13), a location used by Charles Maurin as the basis for pastels in 1894. Knowing that the individual performer played a valuable role in spreading topical ideas also led Maurin, among many others, to focus in some of his pastels on the single entertainer standing in front of a small audience, creating a sense of intimacy and camaraderie with customers. In one such work, the singer Yon Lug, captured while performing, slightly hidden behind a pillar, faces his audience. In the foreground, the dwarf Auguste Tuaillon sells sheet music of the songs that Yon Lug sings. This allowed the audience to sing along if they wished and at the least to follow the performance more closely. The number of posters, prints, and even paintings by countless artists of the period reveal their fascination with the Parisian nightlife during a time when the city increased its fame as a place that never slept, where there was always something happening, especially in the world of the café society.[13]

Certain artists, especially Henri de Toulouse-Lautrec but also Henri Somm, became devotees of dance halls, which featured specific performers. As Toulouse-Lautrec dedicated his work to those at the Moulin de La Galette, the cabaret of Aristide Bruant, or the Moulin Rouge, his fame as an iconographer of entertainers spread. He became an intimate friend of Yvette Guilbert, May Milton (Fig. 14), La Goulue, and, especially, Jane Avril (Fig. 15). Through his paintings and specifically his posters Toulouse-Lautrec made these performers more famous than they would have been on their own, long forgotten after their performing days had ended. He spread their features, poses, and attitudes far afield through his imagery, which became a form of propaganda for the importance of these figures as creative types who were active in constructing a rich and original urban environment. As they strolled the streets of Paris, people were exposed to the posters advertising famous performers; they easily recognized them and took note of the performance sites and, perhaps, patronized the places where their preferred singer, actor, or dancer appeared. Whether patrons went

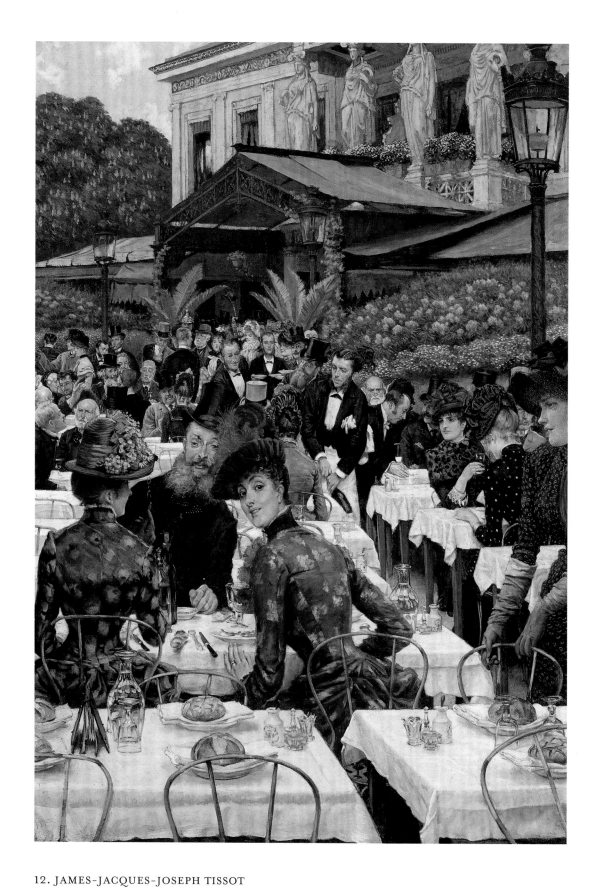

12. JAMES-JACQUES-JOSEPH TISSOT

The Artists' Wives, 1885

Oil on canvas, 57½ × 40

Chrysler Museum of Art, Norfolk, Virginia,
Gift of Walter P. Chrysler, Jr., and the Grandy
Fund, Landmark Communications Fund, and
"An Affair to Remember" 1982, 81.153

13. CHARLES MAURIN

Bal des Quatr'z Arts, 1894

Pastel on paper, 29⅜ × 24

Jane Voorhees Zimmerli Art Museum, Rutgers,
The State University of New Jersey,
Gift of Carleton A. Holstrom, 1986.0884

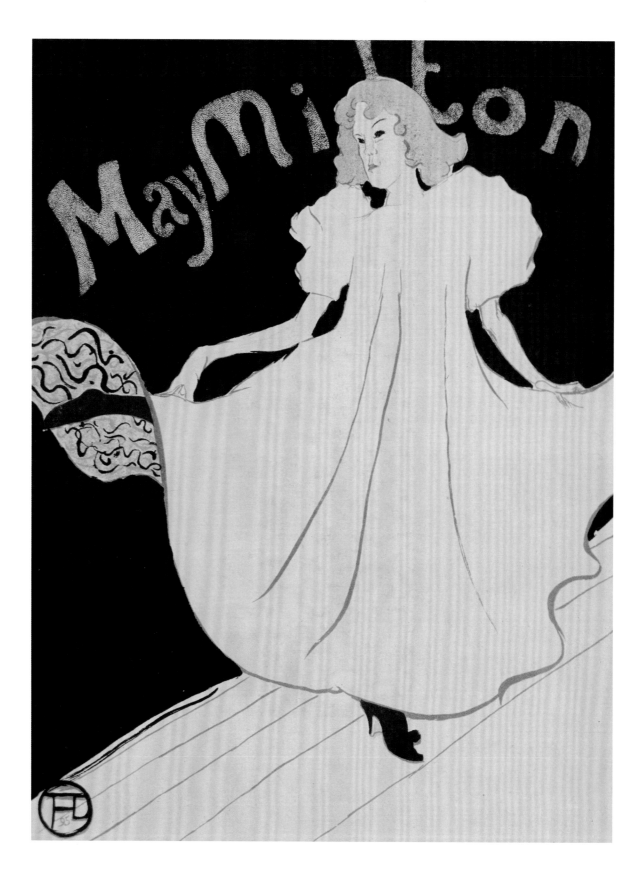

14. HENRI DE TOULOUSE-LAUTREC

May Milton, 1895

Lithograph on paper
31 × 23½

Private collection

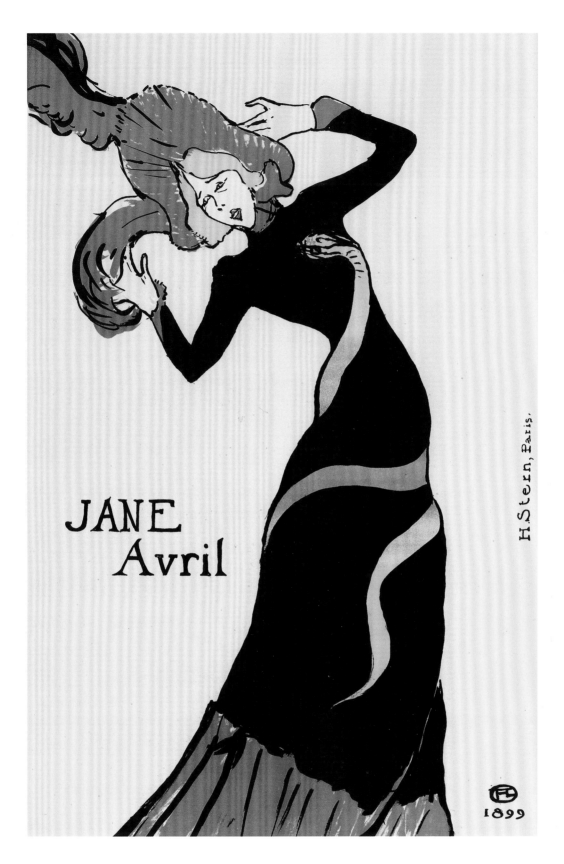

15. HENRI DE TOULOUSE-LAUTREC

Jane Avril, 1899

Brush lithograph in four colors on wove paper
22 $\frac{1}{16}$ × 14 $\frac{3}{16}$

San Diego Museum of Art, Gift of the Baldwin
M. Baldwin Foundation, 1987:103

to Montmartre or other locations dedicated to entertainments, their presence meant that Parisian nightlife was always lively and creativity was valued.

Toulouse-Lautrec's friendship with Jane Avril is well known, although the specifics of how the relationship started, evolved, or how close it was have never been satisfactorily examined.[14] In some prints and paintings by the artist, Avril is seen as a denizen of the street, a melancholic streetwalker, lost in thought, while managing to remain aloof. This is the same attitude that Toulouse-Lautrec reveals in her performances in dance halls. Avril is often far away, removed in time and space, even as she vigorously, even furiously, dances onstage, making us wonder what drove her to live the way she did or what made her dance so wildly. Knowledge of her life, her illegitimate birth, and her stay in the Salpêtrière Hospital under the care of the famed Dr. Charcot were probably general knowledge among the artistic elite,[15] but these factors do not account for the numerous times that Toulouse-Lautrec was drawn to Avril's personality in his work. Perhaps they were kindred souls, damaged individuals, whose precarious inner lives created a mysterious bond between them. Toulouse-Lautrec was mesmerized by creative commitment, by anyone dedicating himself or herself to a craft and achieving something significant—another reason for Toulouse-Lautrec's obsession with Avril. For him, her performances became a sign of intense commitment and personal passion.

Whatever the reasons for this relationship, and they were many, Toulouse-Lautrec seized the opportunity to use Avril as his model for the lithographic poster that advertised a new cabaret, the Divan Japonais (Fig. 16). The silhouetted image of Avril at the new theatrical space was a subtle ploy. She appeared not as a performer but as a famous visitor accompanied by a male friend, whose position in the audience added panache, a note of contemporaneity and the cachet of being seen with a star entertainer of the era. By 1893 Avril was seen as a purveyor of artistic culture, as a participant in active nightlife, and as a visitor to the creative scene even if she was not a performer on any given night. In fact, at the time that Toulouse-Lautrec used her as the principal figure in the poster for the Divan Japonais she had apparently not danced for more than two years.[16] In this poster, she has become a witness to the creativity of others, and their ambassador, similar to the way in which her lover Maurice Biais was to use her inside the space of La Maison Moderne in his poster of 1900 (see Fig. 1).

Divan japonais, with its oblique spatial angles, its handling of space, and its overarching simplification of pattern, has become one of the seminal images in the revolution of color printmaking during the 1890s.[17] Aside from its visual originality, the meaning of the print has remained elusive, largely because of the personality of Jane Avril. Since she seems to have been an artist herself and may have collected the works of others, she held a position of considerable importance among the members of the café society of the 1890s. It is for this reason that Toulouse-Lautrec used her image at the center of the poster.

Another performer who attracted the attention of Toulouse-Lautrec was the English dancer May Milton, who appeared on the Parisian stage for only one season. She then departed unceremoniously for New York and was apparently never heard from again (see Fig. 14).[18] The reasons Toulouse-Lautrec wanted to immortalize Milton may be similar to those that drew him to Avril and all the other performers he made famous: he was attracted by their personalities and inherent qualities, even more than their talent. In the case of Milton, despite the fact that critics at the time attacked her looks and her performance, Toulouse-Lautrec created a mesmerizing poster for her American tour.

When Toulouse-Lautrec turned to Aristide Bruant he found a counterpart to the mystique of Jane Avril, yet with a decidedly different emphasis (Fig. 17). With Bruant, Toulouse-Lautrec moved away from light entertainment to focus on an avowed populist whose performances and songs were filled with a compassionate concern for the poor and the underprivileged. In fact, the fame that Bruant garnered from his performances during the 1890s demonstrated that the urban scene had room for performers who spoke to the masses as much as to one another.

Wearing a readily understood uniform—a large floppy hat, red scarf, large leather boots, bulky pants, and often holding a walking stick—Bruant embodied active bohemianism. He wanted the young to become as committed as he was to the improvement of the conditions of the city; he also called attention to the mistreatment of the working class. As did images by Steinlen and Chahine, Bruant spoke about the urban wasteland that existed around the core of Paris.[19] He opposed the Hausmannization of the city, with its extensive demolition and reconstruction campaigns, calling attention to the sadness and deprivation of the poor in songs and poems that advocated an attitude of social concern. More than any other café performer, Bruant was popular with the people: they came to hear him and to see him. He reiterated one of the primary strains of urban society—the presence of a devastating poverty that was crippling to the lower classes.

Toulouse-Lautrec did a number of lithographs of Bruant that are a testimony to the performer's appeal to a public hungry for larger-than-life personalities. His sympathy with Bruant's message and the way in which the message was encapsulated in the personality of a performer engaged the artist on a profound level. Clear about his perceptions and with his motivations for siding with individual performers recognized, in his posters Toulouse-Lautrec reinforced the atmosphere of diversity that ran through Paris at the end of the nineteenth century.

Another artist was also involved with popular performances at the end of the century: Georges Seurat. In his *Study for "Le Chahut"* (Fig. 18), the painter focuses on the dance hall where the quadrille, or *chahut*, was performed. The openly provocative nature of the dance and the fact that members of the audience gawk at the stage as if mesmerized and tantalized at the same time suggest

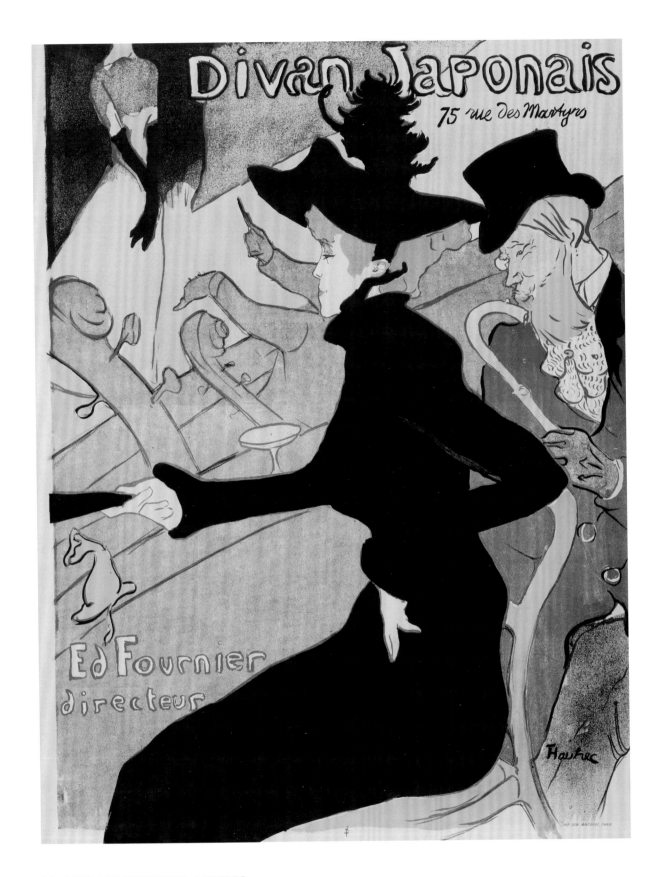

16. HENRI DE TOULOUSE-LAUTREC

Divan japonais, 1893

Lithograph on paper, 31½ × 23½

Edition: Unknown. Publisher: Édouard Fournier, Paris. Printer:
Edward Ancourt, Paris. The Museum of Modern Art, New York,
Abby Aldrich Rockefeller Fund, 97.1949

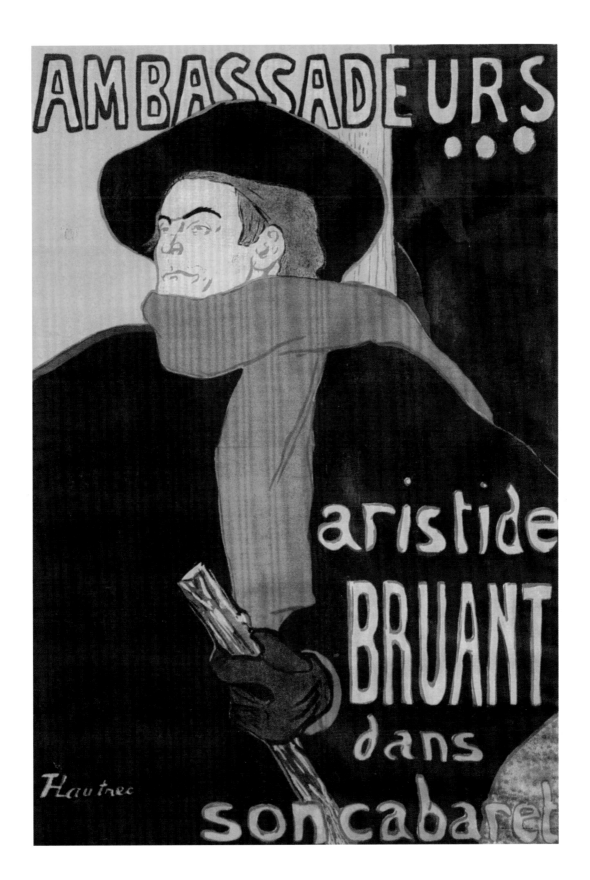

17. HENRI DE TOULOUSE-LAUTREC

Ambassadeurs: Aristide Bruant in His Cabaret,
circa 1890

Lithograph on paper, sight: 53 × 37

Scott M. Black Collection

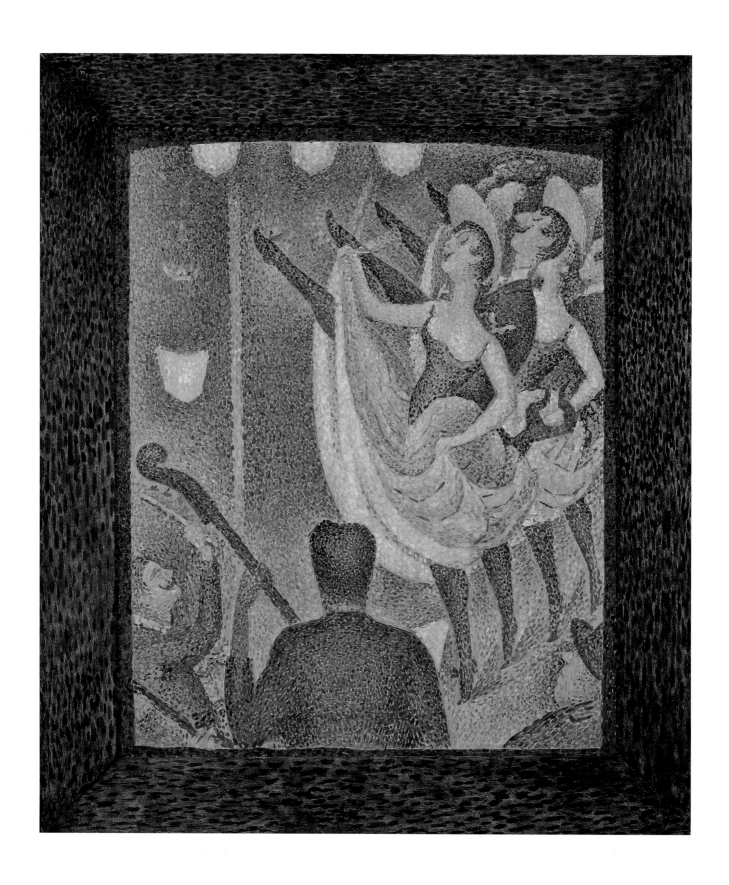

18. GEORGES SEURAT

Study for "Le Chahut," 1889

Oil on canvas, 21⅞ × 18⅜

Albright-Knox Art Gallery, Buffalo,
New York, General Purchase Funds, 1943

that this was a moment of high excitement at odds with the meticulous, methodical way in which the finished painting and its studies were orchestrated. Once again, as a sense of experimentation gripped the artistic community, the underlying themes artists used reinforce how much they were a part of the performances of their own time.

THE PUBLIC ARENA: PUBLICITY

While art often focused on the lower classes during the closing decades of the nineteenth century, artists were also interested in other contemporary issues. They memorialized not only the principal performers of the day but also unusual sites, from the Palais de Glace, as in the posters of Jules Chéret, to the ways in which different products were advertised. Even books were promoted through posters including, for example, Victor Joze's *Babylone d'Allemagne*, in a work by Toulouse-Lautrec (Fig. 19).

This particular image, which also functioned as the cover for Joze's book, brought increased attention to Toulouse-Lautrec. The reason for this was twofold: first, the book emphasized German debauchery at a time when hatred of Germany was at its peak in France; second, the image itself provoked debate. A caricature of the kaiser, standing in a guardhouse at the left, observing the hindquarters of a horse, calls the intelligence of the German leader into question. The notoriety of this imagery led to Toulouse-Lautrec's being commissioned for a series of posters that advertised people or products then in fashion.[20]

During this period, from January to May 1896, Toulouse-Lautrec made seven posters, but then none until 1898–1900. These commissioned posters were different from those he had made earlier, for the artist now worked for others, rather than for himself. Exuberant and filled with fanciful shapes, the images also contain overtones of bawdy humor. They included a poster for L'Artisan Moderne, a designers' collective of ten shops that sold limited editions of jewelry and home decorating objects (Fig. 20). The poster shows an elegantly dressed "repairman" making a house call; he finds the mistress of the house—seen in the foreground—in her bed, as the servant reacts to this intrusion with a degree of shock. Curiously, the model for the repairman is Henri Nocq, a Belgian jeweler, who believed that Toulouse-Lautrec was mocking him in this portrayal. Toulouse-Lautrec could have been satirizing the growing fad for Arts and Crafts objects since the idea of a designer, or workman, paying a house call on a young woman to fix her objects smacks of satire. It also suggests that Toulouse-Lautrec was not taking the new fad for decorative art objects, or the shops selling them, very seriously.[21]

The poster *Troupe de Mlle Églantine* (Fig. 21) was also finished at this time. The poster, showing a group of dancers onstage, was designed to promote

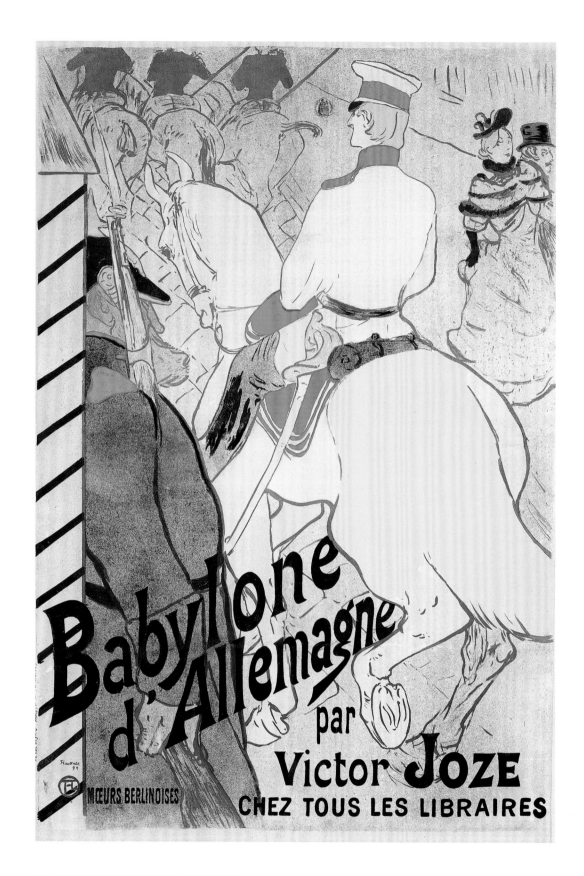

19. HENRI DE TOULOUSE-LAUTREC

Babylone d'Allemagne, 1894

Lithograph on paper, 49 × 33

Scott M. Black Collection

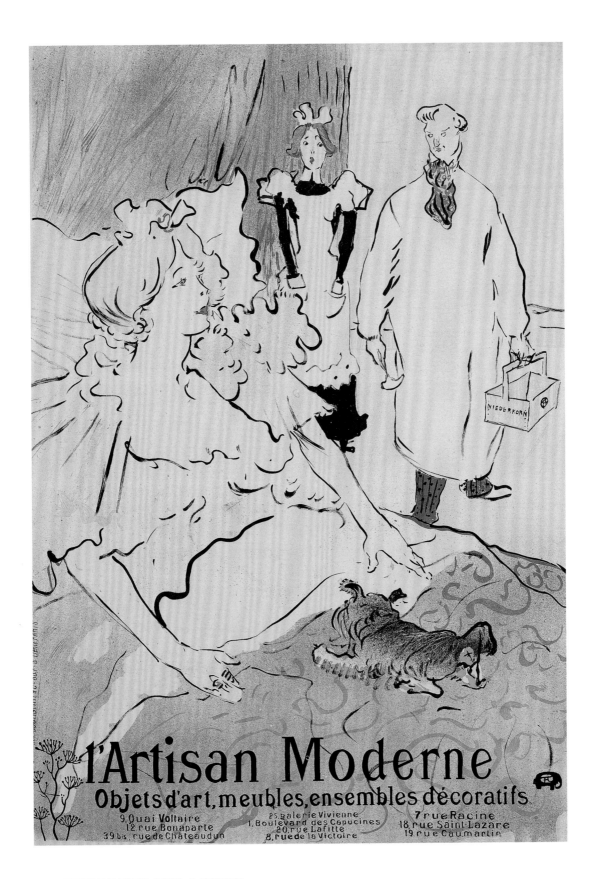

20. HENRI DE TOULOUSE-LAUTREC

L'Artisan moderne, circa 1890

Lithograph on paper, sight: $34\frac{1}{2} \times 24\frac{1}{2}$

Scott M. Black Collection

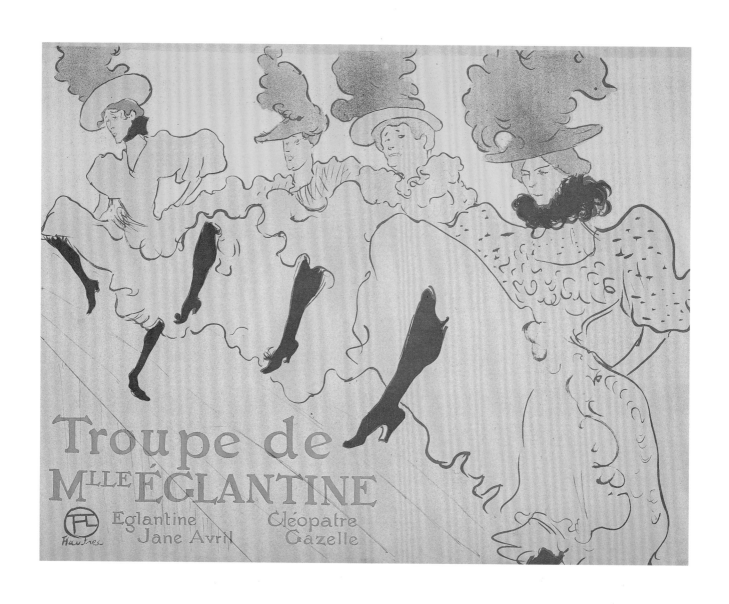

21. HENRI DE TOULOUSE-LAUTREC

Troupe de Mlle Églantine, circa 1890

Lithograph on paper, sight: 24 × 31 ¾

Scott M. Black Collection

Avril's performances in London. She is seen dancing in the foreground, while a chorus of three other dancers, all wearing red wigs, accompanies her, much like a group of backup singers today. One wonders if Avril had a hand in the creation of the posters Toulouse-Lautrec or any other designer made for her. As she seems to have been a visual artist herself—even though one of dilettante status—and as we learn about her artistic tastes through the writings of her friends, lovers, and casual acquaintances, most of them artists, we might speculate that Avril had a keen artistic sense that influenced the artists who created posters or advertisements for her.[22]

In 1896 Toulouse-Lautrec was commissioned to design a poster for his friend Louis Spoke Bougle, who was marketing a new bicycle, which went faster because it used the Simpson lever chain. The scene is set at the Velodrome Buffalo, a circular track, where a bicycle race is taking place (Fig. 22). The edge of the poster cuts off the far ends of the track, but in the center of a grassy oval a band is playing as racers move around and around, circling the track. Standing in the center are two important players: the manufacturer of the Simpson bicycle chain and Spoke Bougle, Toulouse-Lautrec's friend, who, as noted in the lower left of the poster, was the promoter of the system in France. In the background is the *peloton*, the pack of racers; in the foreground is a lone rider who seems to be overtaking two identical riders on a tandem bicycle. Carefully drawn by Toulouse-Lautrec on the bicycle at the left is the impressive Simpson lever chain—the product that was being advertised.

As has been pointed out by Julia Frey and others, the poster could demonstrate Toulouse-Lautrec's ability to use and absorb photographic sequences that he had seen in the photographs of Étienne Marey.[23] This is only a suggestion, for there is another possibility: five-man bicycles, although not common, might have been used at the velodrome. Hence, the bicycle in the background could refer to this new contraption. Once again, Toulouse-Lautrec has humorously done several things. First, he has drawn attention to a new invention that was being used as entertainment in the velodrome by noting that the single bicycle is all-powerful and that it can go faster than many other racers using conventional bicycles, even those using more manpower. Clearly also, Toulouse-Lautrec advertises the fact that races were becoming a popular form of entertainment and, in a fitting way, uses an urban commonplace to combine his brand of whimsical humor with his ability to promote a new product. Furthermore, the poster situates Toulouse-Lautrec directly at the center of a new urban phenomenon, bicycling, which was all the rage during the 1890s for both men and women. Since he was an avid sportsman who, like Degas, went to the horse races, he embraced the bicycle as a new outlet for his passions, which he was able to personalize through his friendship with Spoke Bougle.

From all of these images it is clear that artists like Toulouse-Lautrec had ample opportunity to use their talents in lithography to help foster an atmo-

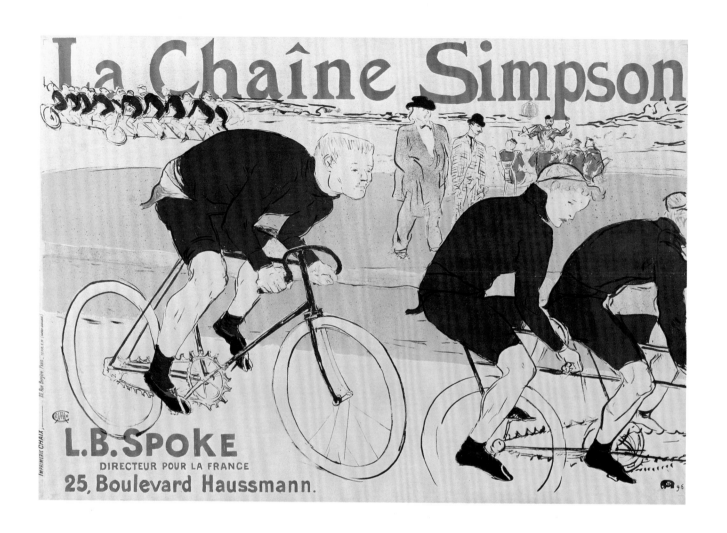

22. HENRI DE TOULOUSE-LAUTREC

La Chaîne Simpson (*The Simpson Chain*), 1896

Lithograph on paper, 33 × 47

Musée Toulouse-Lautrec, Albi, France

sphere of intense commercial activity. All products were subject to advertisement, and posters could be found everywhere in Paris. Even after new laws were enacted to regulate the placement of images on the streets, posters were still found on walls. A veritable poster revolution had arrived. It provided work for many artists who, in addition to providing illustrations for magazines, newspapers, or the book publishing trade, could now find employment as poster makers.

A large number of the posters were also created for the Paris Exposition Universelle of 1900. This was at the beginning of the era of the motion picture, and, to let people know about the new invention, printmakers produced very large lithographs, some of which resembled the imagery of Steinlen. Since the promoters of the motion picture wanted to reach a mass audience, it was crucial that the graphic design be vernacular in style, thus necessitating the participation of more traditional artists, such as François Flameng (Fig. 23). If they were not advertising technological innovations or particular products, posters were used to advertise newly opened shops, such as Meier-Graefe's La Maison Moderne, the fashionable new emporium dedicated to art for the home. Manuel Orazi's poster (Fig. 24) is significant not only because it aims to attract younger visitors but also because it contains a symbolic narrative linked to one of the most beautiful women of the era, Cléo de Mérode.[24] As a marketer with an agenda different from that of most art dealers, Meier-Graefe had opened his store in 1899 with the avowed objective of reaching a younger clientele than the one frequenting other art boutiques in Paris. By positioning a beautiful young woman inside the shop who is wearing elegant jewelry created by contemporary jewelers and who is seated in front of other decorative art objects, situated in a cabinet behind her, Orazi reveals that he understood Meier-Graefe's message. His shop, and the artwork in it, was designed for those with the most contemporary tastes, that is, a young audience, open to Meier-Graefe's internationalist vision.

The message in the print was also subliminal. The young woman admiring and wearing jewelry is also one of the most beautiful women of her generation. Cléo de Mérode had first come to the attention of the public as a dancer; by 1900 she occupied a position as the premiere fashion model of her era.[25] To

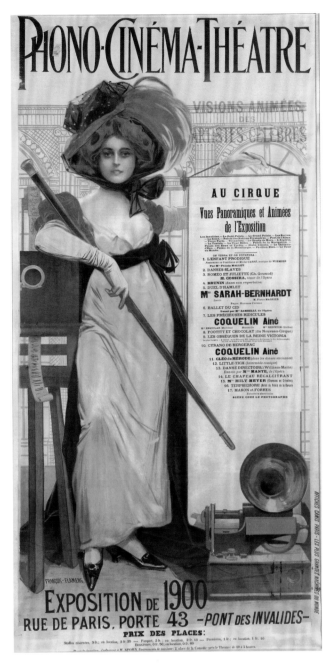

23. FRANÇOIS FLAMENG

Phono-Cinéma-Théâtre/Exposition de 1900, 1900

Lithograph on paper
98 1/16 × 48 1/2

Jane Voorhees Zimmerli Art Museum, Rutgers, The State University of New Jersey, 2001.1492

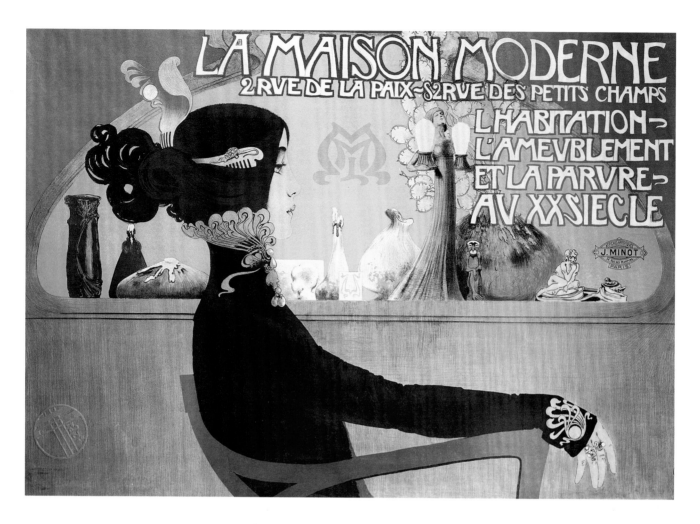

24. MANUEL ORAZI

La Maison moderne, circa 1902

Musée des Arts Décoratifs, Paris

picture her wearing actual or imagined jewelry on a poster was a visual coup. De Mérode's entrancement with the objects she is wearing and the ambience in which she is seated went far in suggesting that Meier-Graefe's tastes were stimulated by his desire to demonstrate his interest in chicness. By choosing Cléo de Mérode as his muse, Orazi proved that he understood Meier-Graefe's intention quite well: that he and, by extension, Meier-Graefe, could reach the masses only by using an iconic statement that many could immediately recognize. Similar to showing Jane Avril coming into the gallery, the presence of Cléo de Mérode wearing elaborate jewelry made a fashion statement. Once again, as in the Avril poster by Biais, the message was linked to the visualization of a personality with whom people—especially the young—could identify. By doing this, Orazi and Meier-Graefe instigated a commercial strategy destined to have a lasting impact on the marketing of art using current celebrities. It suggests a pattern still very much in place today.

II

HIGH LIFE: CONTRASTS FOR THE FASHIONABLE ELITE

As the Third Republic became more firmly established in France, the government was eager to maintain the values of home, family, and country lest France

fall further behind other European nations.[26] Family life was being challenged by the declining birth rate and the loss of its manpower. Germany, for example, maintained a far steadier birth rate, giving her militaristic inclinations a much stronger base of operation. The military collapse in 1870–71 had also left France demoralized. It remained the responsibility of the Third Republic, in all its political permutations, to shore up the psyche of the nation, while making sure that economically, educationally, and aesthetically the country returned to a firm footing. Some even called for *revanche* (revenge), an issue that was not going to be settled until after World War I.[27] Within the arts community, writers and aestheticians eagerly supported the creation of a national identity, one that stressed the undying principles of the French Revolution now applied to a new century. Muralists were called on to visualize the theme of the "good life," vital to the well-being of the family and its enjoyment of the fruits of its labor while it helped build a strong, tolerant, and united nation. The principles to be pictured were the same, whether the muralist was Puvis de Chavannes, working in the Panthéon, or Victor Prouvé, creating a mural for the city hall of Issy-les-Moullineaux.[28]

Crucial to a discussion of how France regained its equilibrium and its artistic prestige during the Third Republic is the way in which artists, designers, craftsmen, and collectors recognized that it was essential for the country to renew itself visually. Painters, sculptors, and designers were not to rely on past traditions; historicism, which was still influential, was challenged by innovative tendencies that broke fresh ground. Among these new trends were ways in which the art, culture, and the vision of Japan provided a creative spark leading to new design practices in architecture, painting, graphic arts, and the applied arts, bringing new forms and shapes and more light and brighter colors to the home environment. While this narrative has been discussed elsewhere, how it touches the vision of high life during the last decades of the nineteenth century will be briefly presented here. In the process, a view of nineteenth-century urban life, seen from a vantage point of considerable wealth and luxury, will demonstrate that artists worked on all sides to create a vision of a society in transition.

JAPONISME AND ESPAGNOLISME: THE FADS

During the closing years of the Second Empire, in the late 1860s, as Napoleon III struggled to maintain his authority while opposing parties hoped to reform his reign, the art scene prospered as the influx of money from expanding commerce and industry filtered from the very rich to the growing middle class. Eager to share in the new era of consumption and to take part in all the refinements historically reserved for the very rich or the aristocracy, the *nouveaux riches*—who had made their wealth in new technologies—were keen to display their position by acquiring material objects. Concurrent with these political and economic changes in France, and following the opening of Japan to the West by the American Commodore Matthew Perry in the mid-1850s, the art of

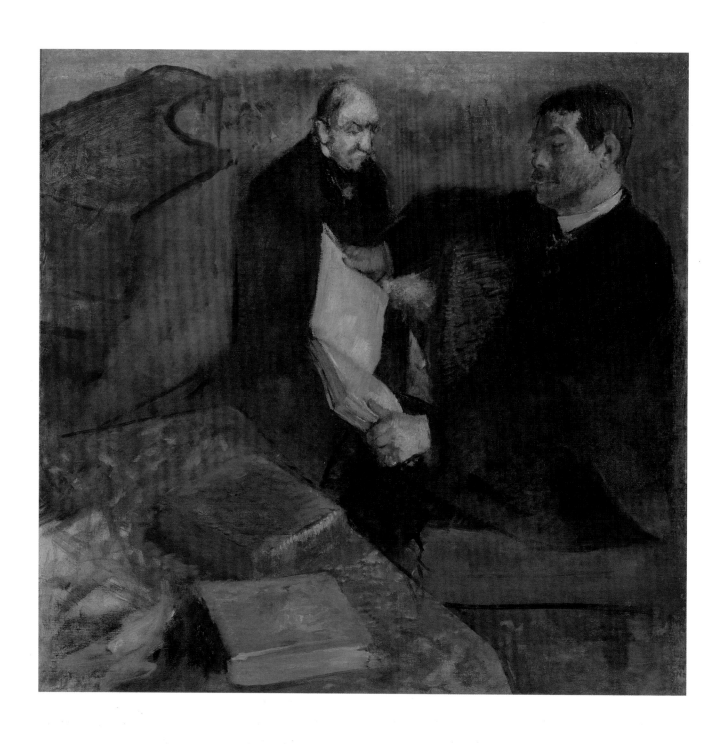

25. EDGAR DEGAS

Pagans et le père Degas (*Pagans and Degas's Father*),
1888–94

Oil on canvas, 32 × 33

Scott M. Black Collection

Japan flooded the West, especially Paris and London. At first objects of all kinds, including ukiyo-e prints, fans, and kimonos, were seen as curiosities but, eventually, as significant art objects with considerable intrinsic value. It is the confluence of these two phenomena—the accumulation of wealth and the arrival of a strange and delightful new art—that precipitated an unstoppable design reform in all media. People with a sense of inventiveness secured objects for little cost. As the century progressed, and as an art market for Japanese imports became better established and collectors more knowledgeable, the quality of the objects changed. More important and more ancient art objects arrived, leading to the creation of a series of impressive private collections, such as that of the art critic Philippe Burty, whose collection was auctioned after his death in 1891.[29]

The closing years of the Second Empire also witnessed a concerted interest in Spain and Spanish culture. Spanish performers went to Paris to work in theaters while French artists and critics traveled to Spain, especially to Madrid, where they appreciated the works of such artists as Diego Velázquez and Francisco Goya. Spanish music, dance, theater, and visual art were influential in molding tastes under the name of Espagnolisme. Although this tendency did not become as widespread as Japonisme, it did influence the visual arts, especially in works by Edgar Degas such as his *Pagans et le père Degas* (Fig. 25). As examples of the Second Empire interest in cultures outside France, these works reveal an early fascination with multiculturalism. Japonisme, however, became more substantial and long-lasting, partly because of the fact that commercial interests were more varied.

By 1869, in addition to Burty, a sizable group of distinguished collectors emerged who were amassing substantial and noteworthy groups of Japanese objects. When the Musée Oriental opened in 1869, objects from many of these collections were put on display, and members of the public as well as potential new buyers went to study them. Included in this group was James Tissot, himself an ardent collector of Japanese objects, especially kimonos. In several of his paintings, he recorded the way in which young women were mesmerized by pieces they saw in the exhibition (Fig. 26). Fashionably dressed, the women

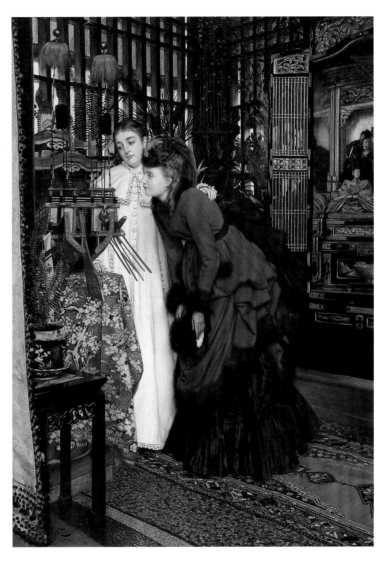

26. JAMES-JACQUES-JOSEPH TISSOT

Young Women Looking at Japanese Articles, 1869

Oil on canvas, 27¾ × 19¾

Cincinnati Art Museum, Gift of Henry M. Goodyear, M.D., 1984.217

look intently into a vitrine where objects have been displayed or at objects on a stand. Their enthusiasm for the discoveries is evident, even palpable. In these paintings Tissot effectively documented the young women's surprise when faced with the strangely fascinating objects they cannot readily understand. The fact that Tissot repeated the theme of young women looking at Japanese objects so many times attests not only to his fascination with the art itself but also with the craze for Japanese art that was becoming manifest in Europe as well as in the United States.

Jules Lefebvre, a firmly entrenched academic painter and eventually a significant teacher at the liberal Académie Julian, showed a similar interest in Japan in *Une Japonaise* (Fig. 27).[30] Here, a coquettish Western young woman, coyly peering over the top of an open fan and wearing a brilliant red kimono, strikes a seductive pose intended to lure a viewer or potential collector. The tone of the painting is lighthearted; the fact that the woman is dressed in a kimono reveals that the taste for wearing Japanese dress was becoming widespread. Completed in the Third Republic, when France was trying to regain her sense of artistic superiority, the painting by Lefebvre shows the artist playing to a public audience that supported the craze. As an academic artist with a large following among the cultured elite, Lefebvre took the time to complete a work extolling Japonisme, a fact not lost on his wealthy clients. He certainly helped promote the taste within a new circle of admirers.

JAPONISME TAKES COMMAND

The taste for Japanese art quickly permeated all the visual arts in France (and elsewhere), leading ceramists to borrow motifs from Japanese prints or to use as visual conceits, such as Félix Bracquemond often did. These ideas were assimilated from various Japanese sources that he knew intimately. In some cases, Bracquemond's abstractions from Japanese prints predate the Art Nouveau movement; they suggest that his work in the decorative arts, an area that he helped revolutionize, was in the forefront. Bracquemond's use of Japanese motifs in the applied arts is a key development in taste. His colleagues and friends, including the printmaker Henri Rivière, were also staunch supporters of the taste for Japanese art. Tissot recorded, in a very realistic manner,

the way that people came into contact with Japanese art and the fascination it exerted. Lefebvre made a game of the fascination: the woman is wearing a kimono knowing that she is playing a dress-up game that might amuse the viewer, just as she is amusing herself. Rivière, by contrast, attempted to assimilate the design concepts of Japanese art, applying them to Western scenes. In a certain way, the three artists' works encapsulate the three levels of accommodation accorded Japanese art as it was adapted in the West. It progressed from mere acknowledgment, to superficial usage, to actual understanding.[31] Rivière assimilated the various views of Mt. Fuji he saw in ukiyo-e prints by Hokusai or Hiroshige and adapted them to his depiction of the Eiffel Tower (Fig. 28). He created a series of prints where the shape of the most modern structure in Paris is seen from different angles and at different times during its construction.[32] The result is that we approach the Eiffel Tower not through Western eyes but through the filter of Far Eastern eyes, as the different views of Mt. Fuji by Hokusai or Hiroshige help transform the Eiffel Tower into a sacred form for the burgeoning machine age. Rivière clearly responded to the way Japanese printmakers understood the sacred qualities of Fuji as it dominated the landscape, just as the Eiffel Tower was to dominate the cityscape of Paris. This remarkable metaphoric comparison brings another dimension to our understanding of the urban environment, one that is both unusual and witty.

In comparison with the works by Rivière are paintings and a series of lithographs by Pierre Bonnard completed at the end of the 1890s. These images, including *Dans la rue*, *The Boulevard*, and *Street Corner Seen from Above* (Fig. 29), emphasize the ways that Bonnard had assimilated the bird's-eye vantage point found throughout Japanese prints. In applying this effect to a series of images depicting Parisian street life, Bonnard, like Rivière, reinforced the Japanese design principles that had helped advance lithography to a more creative, modern stage. The elevated viewpoint not only helped a two-dimensional surface pattern emerge effectively in the works but also gave rise to new angles from which the urban scene could be depicted.

Georges Lacombe is another painter who responded to Japonisme. His *Gray Sea* (see Fig. 71) shows an assimilation of prints by Hiroshige, such as his *Whirlpool at Naruto*. Painters who actually traveled to Japan created images based on their experiences there. This is the case with Louis Dumoulin, whose *Carp Banners in Kyoto* (Fig. 30), painted in 1888, references a type of Japonisme inspired by direct reportage. The artist witnessed the scene itself and wanted to make of it an effective representation of reality.

No matter where the inspiration came from, by 1900 Japonisme had permeated all facets of creative life in the city. Artists from all camps—those dedicated to scenes of high life and those essentially exploring more mundane dimensions—drew from Japanese art. It became a universal source that sparked creative challenges.

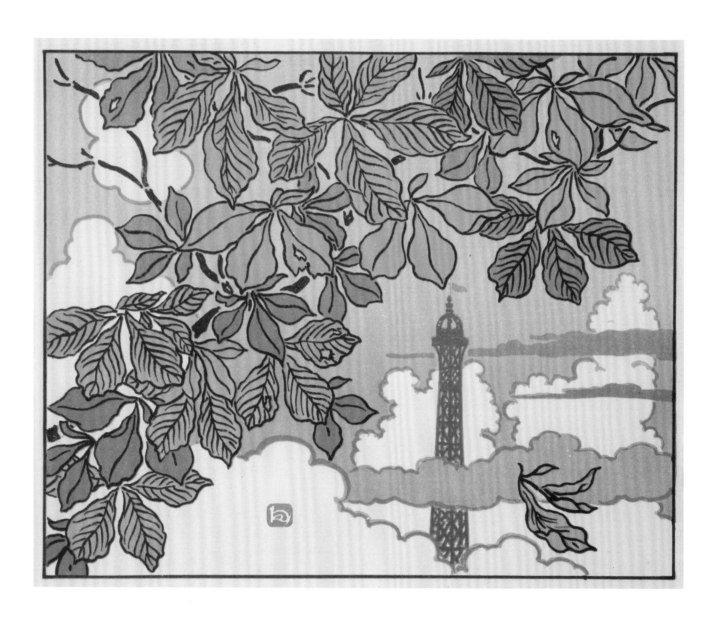

28. HENRI RIVIÈRE

The Eiffel Tower Seen through Tree Branches, undated

Lithograph on paper, 8¾ × 10⁷⁄₁₆

Jane Voorhees Zimmerli Art Museum, Rutgers,
The State University of New Jersey, Gift of
Frederick Mezey, 1997.0261

29. PIERRE BONNARD

Street Corner Seen from Above,
from *Some Scenes of Parisian Life*, 1899

Transfer lithograph in four colors on white wove paper
image: $14\frac{5}{8} \times 8\frac{3}{8}$, sheet: $21 \times 16\frac{1}{8}$

Smith College Museum of Art, Northampton,
Massachusetts, Gift of Selma Erving, class of 1927,
SC 1978: 1-16

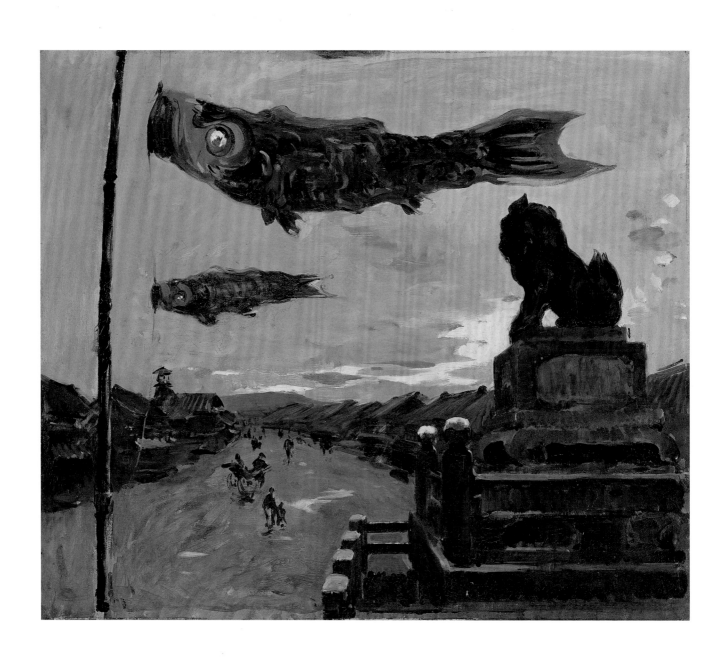

30. LOUIS DUMOULIN

Carp Banners in Kyoto, 1888

Oil on canvas, 18⅛ × 21⅜

Museum of Fine Arts, Boston, Fanny P. Mason
Fund in memory of Alice Thevin, 1986.582

The chaos of life in the inner city, where city dwellers tried to cope with stress and change, led some individuals to escape into anonymity. Not all wanted to be instantly identified, and the fact that so many people dressed the same way, absorbed in the changes of yearly fashion, helped them achieve their goal. Even when the fashionable elite dined at the best restaurants or cafés, it was apparent that the women often strove to make similar fashion statements, and even the men often dressed alike, tried to make the same gestures, and followed the same etiquette. This loss of individuality, the beginning of a crowd mentality, is found in an early stage in the social mores of the era. People watched one another, and in doing so they established codes of dress and behavior that grew increasingly uniform. Some painters, namely James Tissot and Jean Béraud, whom we will discuss later, were sensitive to these subtle nuances in lifestyle. In *The Artists' Wives* (see Fig. 12), Tissot constructed an image that extolled a specific event—lunch on the day of the opening of the Salon—and carefully shows the subtle responses of the actors to place and demeanor.

Although the event depicted here refers to a specific moment, varnishing day at the official Salon, the way in which women and men are situated and dressed suggests much more. Tissot's painting, part of a series celebrating the beauty of the women of the French capital (*La Femme à Paris* [*Parisian Woman*]), reveals that human relationships were becoming overcivilized, meetings were institutionalized, and ritual over substance became the hallmarks of the day.[33] With their tightly corseted bodices, which forced women to arch their backs stiffly, Tissot suggests a rigid control. Rather humorously, one of the women at the foreground table looks out in the direction of a viewer or a new entrant into the event. Rather knowingly she also hints, through her sly expression, that she realizes that the woman at her left is wearing practically the same dress (only the color is different) as she is—obviously conformity had reached its apogee in copycat fashion.

One of the key images in the series was *L'Ambitieuse* (*Political Woman*) (Fig. 31), a work that emphasizes the way in which women were seen as objects to be put on display. Here the fashionable woman, hanging on the arm of a much older man, implies that the man, even though he is much older, is still capable of attracting the attention of young, beautiful women. The male figure is using the *élégante* to enhance his position, since all would turn to look at the stunning individual moving in their midst. This is a compelling work, where it is clear that the other men are whispering among themselves about the older man who has captured the young woman as his prize, his trophy. It is as if Tissot had seized on the quality of pulp fiction to create a visual narrative capable of hold-ing the attention of a viewer much as it would in a newspaper article, gossip column, or serialized story.

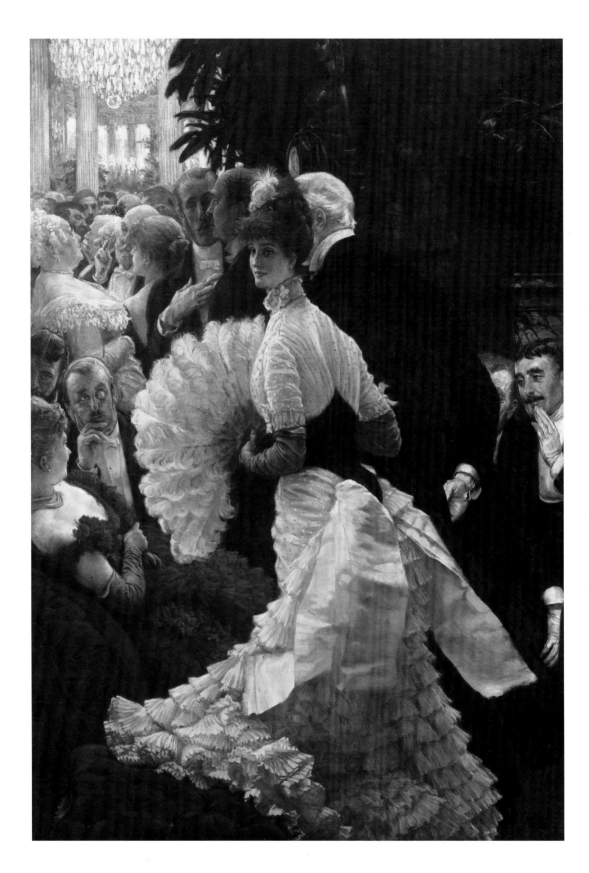

31. JAMES-JACQUES-JOSEPH TISSOT

L'Ambitieuse (*Political Woman*), also known as
The Reception, circa 1883–85

Oil on canvas, 56 × 40

Albright-Knox Art Gallery, Buffalo, New York,
Gift of William M. Chase, 1909

The same sense of unreality that dominates the two previous paintings is found in a third work from the series, *Ces Dames des chars* (*These Ladies on Their Chariots*), in the collection of the Museum of Art, Rhode Island School of Design. These performers exhibit no emotion; they seem completely immersed in their activity, almost as if Tissot were drawing a parallel between their existence and the presence of wax mannequins at, for example, the Musée Grévin in Paris.[34] Unlike Toulouse-Lautrec's psychologically evocative studies of the players in Montmartre, these women seem dominated by the drama of the place, a performance at the Hippodrome de l'Alma. The stately movement of the chariots combined with the glistening light effects of the interior create an impression of unreality. Once again Tissot's image is all about show; he has captured what is artificial, even troubling, in the urban scene during a majestic performance attended by hundreds of people. It is the lack of expression, the coldness of the scene, that reinforces Tissot's ability to see beauty as only skin deep and the urban scene as one of a glittering surface leading toward a sense of cold foreboding.

A similar interest in the ritualistic aspects of Parisian life also infuses the paintings of Jean Béraud, an artist who enjoyed great popularity by painting the well-to-do who moved through the streets of the city's fashionable Right Bank. Whether Béraud was painting *On the Boulevard* (Fig. 32) or *Les Halles* (Fig. 33)— the huge covered marketplace where food destined to feed all Parisians arrived before being distributed to smaller markets, shops, and restaurants—his sharp eye for anecdotal details and his ability to differentiate various social types made Béraud a novelist in paint.[35]

In *On the Boulevard* Béraud shows two scenes in one painting. A policeman eyes a fashionably dressed young woman as she walks down the sidewalk, and two well-dressed businessmen greet one another, suggesting that they are good friends. In the background, a woman examines the windows of an elegant store, while to her left a bearded tourist, guidebook in hand, tries to find his way as he strolls through the central part of the city. Béraud has left no detail untouched, even down to the messenger, the young boy moving rapidly to deliver his message to an unknown destination. By including all these details, the artist showed that much activity took place in the streets and that by recording these aspects of existence, he was able to convey a sense of the pace of Parisian life. Similar to Tissot, however, he often returns to an interest in the superficial spectacle, in the conventions of dress and ritual.

In *Les Halles*, with its various outdoor stalls, Béraud also shows how the city lived. He shows the large display of food, vegetables, and fruits, and people from all strata of society walking about. To the left is a bearded gentleman discussing a sale with a vendor; in the middle, a well-dressed woman, followed by her maid, surveys the many stalls before deciding where she will make her purchases. Like Tissot, Béraud has captured the varied tableaux of Parisian life, more concerned, perhaps, with conveying the spectacle of modern life than exposing the deeper sense of melancholy and personal anxiety lurking behind it.

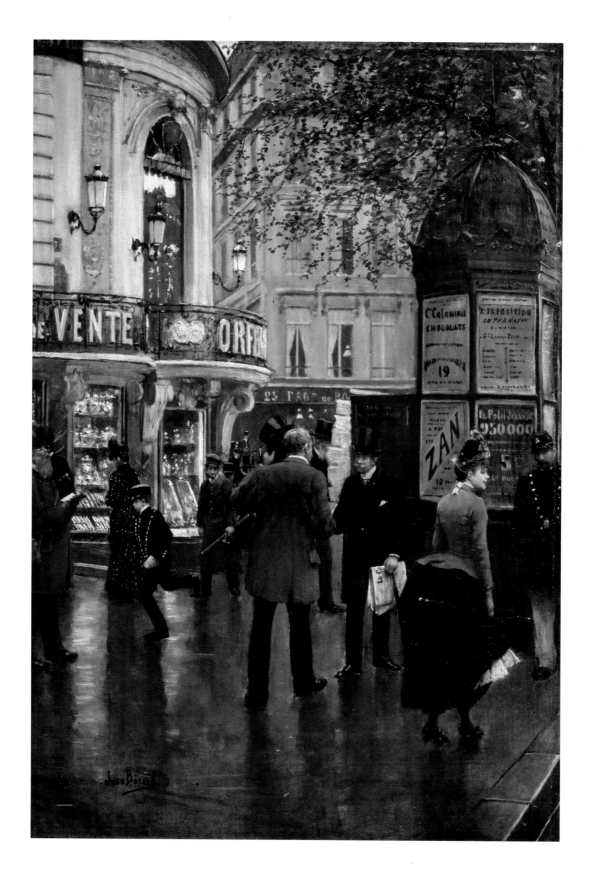

32. JEAN BÉRAUD

Sur le boulevard (On the Boulevard), circa 1888

Oil on canvas, 21 × 14¾

The Haggin Museum, Stockton, California,
1931.391.3

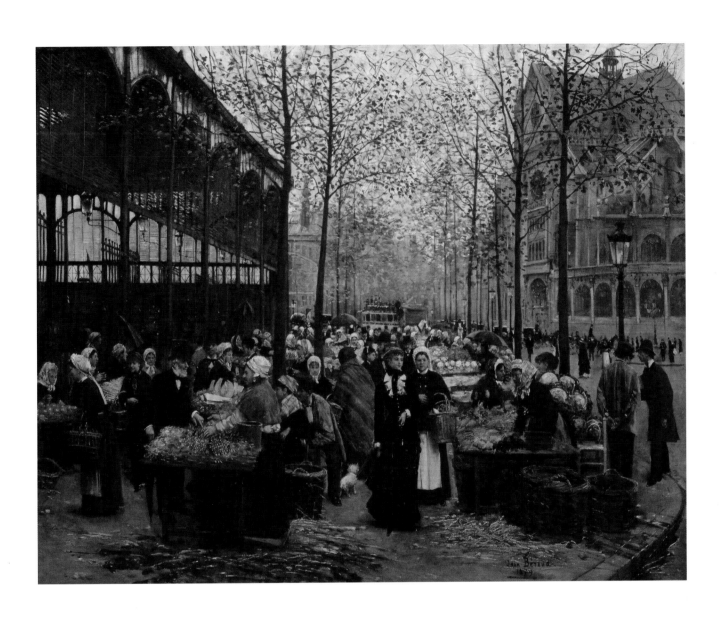

33. JEAN BÉRAUD

Les Halles, 1879

Oil on canvas, 25⅝ × 32

The Haggin Museum, Stockton, California,
1931.391.4

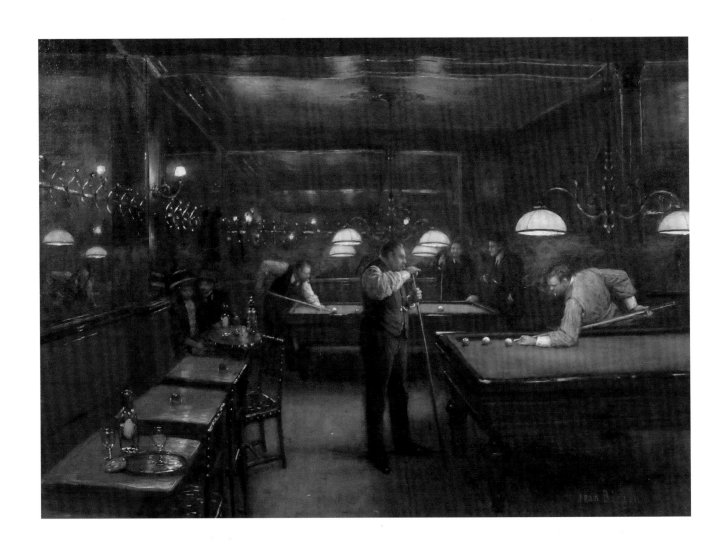

34. JEAN BÉRAUD

Le Café, 1908

Oil on canvas, 17⅜ × 24⅜

Herbert Black

Only occasionally, as in his series dedicated to the game of billiards, or in his series on Christ and the contemporary world, or his sorrowful views of cafés showing customers under the influence of absinthe, does Béraud become more socially conscious. Here, well-dressed gentlemen spend hours with their partners playing a game of billiards (Fig. 34). They inhabit a small, tightly contained room where mirrors on the walls make the room appear larger than it actually is. In spite of this stratagem, the space feels claustrophobic, the atmosphere, heavy with smoke, unhealthy. Dressed in the attire of the period—a dark suit with a vest—several of the men have taken off their jackets and play in their long-sleeved shirts and vests. Some have a cigarette dangling from their lips to suggest the sense of intense concentration, even frustration, with the game. By depicting a scene seldom before seen in paint, Béraud showed one more aspect of urban life, admittedly one few might experience, since the game was played behind closed doors in private clubs or at home, if one had a big enough space, with a few select friends.[36] Billiard parlors multiplied in Third Republic France, and many of the wealthy saw to it that their apartments or villas were equipped with a billiard room, where the men could escape from their wives or girlfriends, to enjoy themselves. Béraud conveys the intensity of the moment, the satisfaction the men experienced at having a space for themselves. In addition, by showing the trick shot of the billiard player at the right, he hints that showmanship was another way in which men enjoyed the pleasures of daily life. One amusing detail, visible in the left corner, is the couple seemingly divorced from what is happening in front of them, as the man tries to capture the attention of the reluctant woman.

In the work of both Tissot and Béraud, as with other Third Republic Salon painters such as Henri Gervex or Albert Besnard, there was a growing appreciation for and study of various aspects of urban life, especially as it reflected the surface glitter of the era. People were learning to amuse themselves, to enjoy carefree moments strolling the city streets, or engaging with friends in games that provided distraction from urban pressures. Third Republic painters found new sites to study and record in their attempts to catalogue the life of high society; it is in these compositions that the wealthy found a visual representation of their lives, a counterpoint to the way in which other artists had focused on the poor and the disenfranchised.

The last group of artists we must consider—a coterie of painters and pastelists who held their own exhibitions, separate from the major Parisian Salons, but who were concerned with the same issues as their academic counterparts but expressed them in a different mode—are the Impressionists.

THE IMPRESSIONISTS IN THE URBAN SCENE

Although the general tendency is to see the Impressionists as a group of landscape painters absorbed in scenes of the countryside, members of the group,

which exhibited together from 1874 to 1886, reflected other interests.[37] A close examination of the various Impressionist catalogues reveals a wider range of themes than generally thought, as some of the Impressionists were portrait painters and still-life painters, and still others, notably Jean-François Raffaëlli, Gustave Caillebotte, and Edgar Degas, were interested in scenes and types from the city and its environs. However, the scenes that the Impressionists favored, even when inspired by the cityscape, often reflected personal hedonistic pleasures, a love of pure color and light, the impressions of movement through a city street. Their paintings are seemingly free of the social implications of those life issues that concerned the people of the street; only on occasion, in Raffaëlli's depictions of ragpickers and outcasts on the fringe of society, do we see distressing issues of social concern.

Were the Impressionists united in rejecting the larger view of city life as well as the realities of a socially involved narrative? Were they, as has been discussed in many publications, selectively aware of the social issues of the day, of the way in which the city was affecting the life and attitudes of many other artists? Or were they not engaged with these issues at all?[38] The answers to these questions cannot be fully investigated here, although placing the Impressionists in the urban environment and comparing their imagery to that of other artists' responses to social problems will help to clarify the situation. It will also provide a way of seeing the Impressionist painters less as the heroes of the momentary and more as a group of painters different from the Naturalists, who did not reject the cityscape entirely but remained selective in what they chose to paint.

A good case in point is the work of Gustave Caillebotte. Although he was trained academically and obviously appreciated some of the early street scenes of Jean Béraud, Caillebotte chose his own path.[39] His paintings reflect the attitudes of a casual stroller, a flâneur who takes in the sights of the city, without being totally absorbed by the living conditions of various classes. This is how Caillebotte constructed his *The Pont de l'Europe* (Petit Palais, Geneva) composition, including the sketches for it, and it is also how he developed his well-known *Paris Street: Rainy Day*, the seminal painting of the Impressionist group that demonstrates how leisure-time activity could be translated into large-scale compositions (Fig. 35).

As a painter of modern life, albeit the life of the wealthy, Caillebotte suggested that life in the city was symbolically composed of scenes of people moving about, such as walking on a rainy afternoon, completely detached from life around them. If we look carefully at these paintings, and if we compare Caillebotte to Tissot, for example, something else becomes apparent. Through the expressions of reserve on the faces of his models and through their robotic movements, Caillebotte has embodied the sophisticated ennui that dominates his compositions. Even though his characters are in the city, they seem not to be engaged with their surroundings; they are emotionless and move mechani-

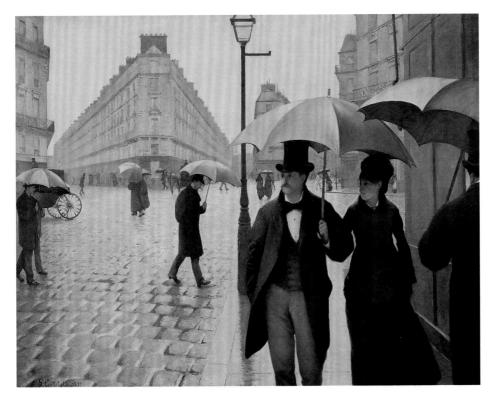

35. GUSTAVE CAILLEBOTTE

Paris Street; Rainy Day, 1877

Oil on canvas, 83 ½ × 108 ¾

The Art Institute of Chicago, Charles H. and Mary F. S. Worcester Collection, 1964.336

cally. The sense of urban isolation, the lack of communication between people, becomes the hallmark of Caillebotte's compositions. Caillebotte, as a man of his time, has grasped what city life does to those who inhabit it, and it is to his detached, photographic style that he owes his ability to render the anonymity of city life.[40]

Caillebotte's paintings are deceptive, unusual. He learned from both sides of the urban equation: those involved with the poor and those committed to a higher lifestyle, the latter reflective of Caillebotte's own background. However, he is not a painter without a point of view. Since he was central to the Impressionist group, serving as their primary maecenas, his works and his beliefs were shared by a few others, certainly by Degas, another painter whose imagery seems linked to the times when it is placed in a context outside that of the Impressionist group.[41] This is one way in which Degas's etching of Mary Cassatt in the Louvre, a seminal image, can be explained: he has used the Louvre as a teaching institution where younger painters often went to study, to be seen, and to discuss artwork with others (Fig. 36).

While Degas is usually given credit for introducing the themes of ballet classes (Fig. 37 and Fig. 38) as well as the world of prostitutes in brothels to the repertoire of nineteenth-century painting, there were other painters, some already mentioned here, who either followed his example or took up these themes on their own. Béraud, for example, treated the theme of prostitutes in some of his large-scale paintings completed early in his career.[42] Degas's examination of the ironess or washerwoman on the street also belies a definite

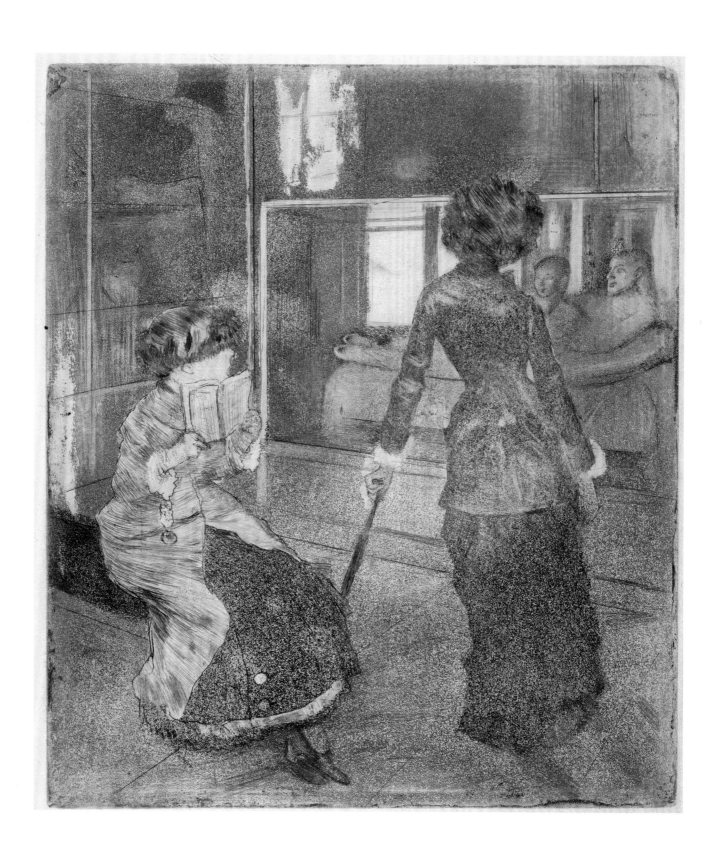

36. EDGAR DEGAS

Mary Cassatt at the Louvre: The Etruscan Gallery, 1879–80

Softground etching, etching, aquatint, and drypoint
printed in black on thin Japan paper
plate: 10⅝ × 9⁵⁄₁₆, sheet: 14 × 10⅝

Smith College Museum of Art, Northampton, Massachusetts,
Gift of Selma Erving, class of 1927, SC 1972: 50-17

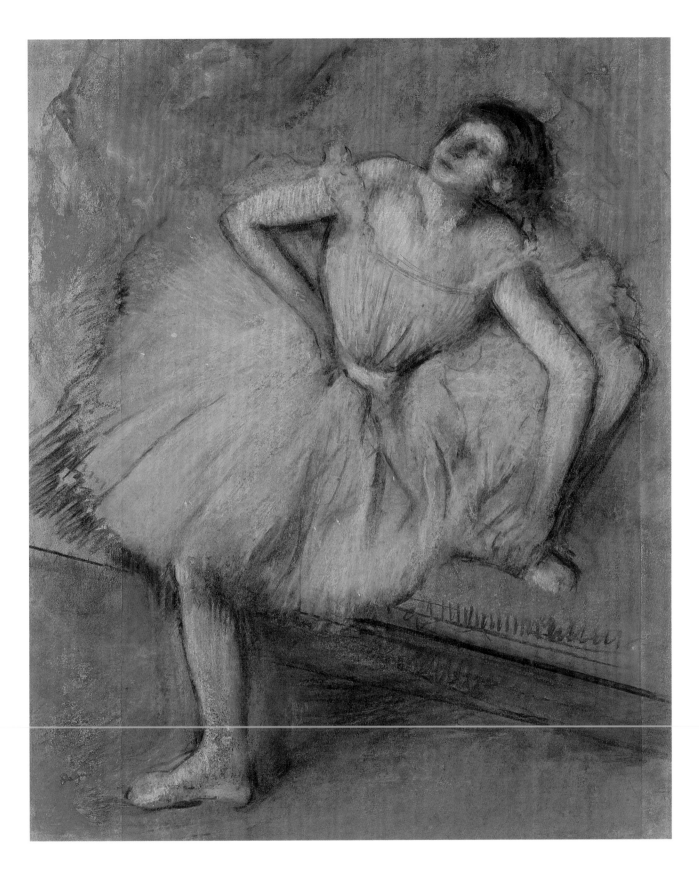

37. EDGAR DEGAS

Danseuse assise (*Seated Dancer*), 1894

Pastel on joined paper, mounted on board
22¾ × 17¾

Scott M. Black Collection

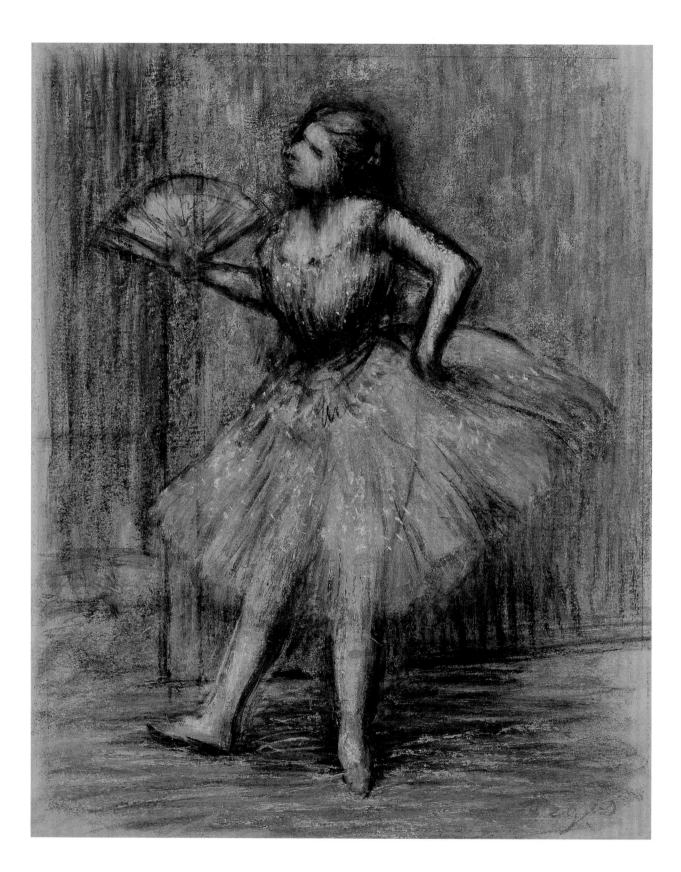

38. EDGAR DEGAS

Danseuse à l'éventail (*Dancer with Fan*), undated

Charcoal and pastel on thin buff paper, laid
down on heavy paper, 19⅛ × 15

Private collection

interest in the people of the city; his sympathetic investigation of prostitutes seated in brothels, waiting for customers, reveals that he was not always a dispassionate observer. The fact that he had a career of importance after the close of the Impressionist exhibitions in 1886 further demonstrates that he had a real impact on painters whose imagery reflected aspects of city life close to his own concerns.

Degas produced private scenes, depicting his circle of friends, who often came from the upper echelons of aristocratic society, that show another side of the artist. Among these is an early painting, *Children and Ponies in a Park* (see Fig. 54), inspired by the painter's long-standing relationship with the Valpinçon family and the times he spent with them on vacation at their estate in Normandy.[43] Here, prompted also by his dedication to horse racing, Degas painted the Valpinçon girls riding ponies and enjoying a carefree moment in a park. Their poses seem to imitate actual racing postures: one girl rides a pony that leaps over the grass while a second child rides off in an opposite direction. The third child, in the foreground, tries to encourage her donkey to get up, an anecdotal detail that is quite humorous. Degas's painting of young horse riders at friends' country estates, beyond being amusing and rather anecdotal, raises issues about urban life and the two worlds that met in its midst: the rich and the poor.

The wealthy, such as the Valpinçon family, often owned large properties in the country—sometimes more than one—where they could spend restful vacations and escape the increasing pressures of urban life. While there, they would have been able to enjoy traditional entertainments. The Valpinçon family, for example, owned a great stud farm at Le Pin, where the young daughters' interest in horses was reinforced, as was Degas's fascination in horse racing. This painting also reveals that families of means were able to escape from the city whenever they wanted, while most city inhabitants were trapped in a monotonous, unhealthy, and uninteresting routine.

A similar interest in moments of quiet escape and thoughtful reverie also attracted Pierre-Auguste Renoir. In his *Confidences* (Fig. 39), the painter has depicted an intimate moment between a young couple seated in a park, where they are both immersed in one another and engrossed in reading a newspaper.[44] It is a moment of enjoyment, suggestive of the way in which the Valpinçon children in the work by Degas played innocently together. Here, these figures are in a dream world of their own making. Since they are situated in a park, isolated from the larger city, it appears that Renoir wanted to convey the Impressionist idyll—escape into a world of delicate atmosphere where the dappled light bathes and soothes the figures while reinforcing an indolent summer moment. By heightening the evocative and tender mood that he has constructed, Renoir suggests that the young couple are two lovers completely immersed in their own thoughts and love for each other.[45]

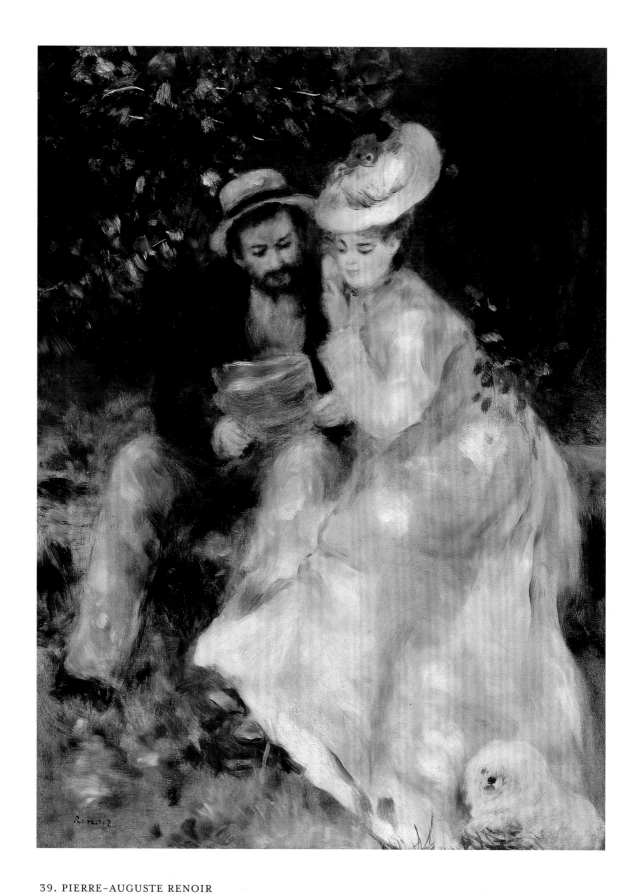

39. PIERRE-AUGUSTE RENOIR

Confidences, circa 1873

Oil on canvas, 32 × 23¾

The Joan Whitney Payson Collection at the
Portland Museum of Art, Maine, Gift of John
Whitney Payson, 1991.62

Mary Cassatt, an American painter in the Impressionist camp who came from a wealthy family, also possessed the qualities of fine breeding and social etiquette that many members of the group extolled. While Cassatt never married and remained close to her family, she was on intimate terms with several Impressionist painters, particularly Degas.[46] Cassatt was mesmerized, even obsessed by the carefree demeanor of children, their sense of innocence. As a portraitist, Cassatt was fond of intimate family moments and grasped the nuances of proper etiquette and ritual. Her pastel *Simone* is both freely observed and belongs to the larger interest the Impressionists showed in intimate moments of family existence (Fig. 40). It is a tradition that Cassatt maintained throughout her career, as it dominates her pastel portraits and her color etchings, the latter being her major contribution to progressive printmaking.

But of all the scenes that best captured the Impressionists' view of the drama of city life, it is their treatment of the bridges and streets of Paris that remain transfixed in our minds. Whether it was Camille Pissarro's version of the Pont Neuf (Fig. 41), one of the oldest bridges in the city, or any other site in Paris, the spirit of the urban center as a stage where individuals from all walks of life moved and gathered provided an important backdrop. In seeing the bridge or the boulevard as a marker connecting all sections of the city, bringing people together if only for a brief moment during the day or night, Pissarro thought of the site as a theatrical set and the people of the city as performers. This belief is equally evident in Pissarro's cityscapes of the 1890s, when, from a high vantage point, he objectively observed the activities of the crowd, moving the figures, the horses, the wagons, and the carriages on the surface of the canvas like a chess player moving pieces until all was resolved (Fig. 42). However, keeping the atmospheric qualities of the Impressionist project and using the design principles of Japanese prints, Pissarro went further in his depictions of the city's neighborhoods.[47] These late compositions are symbolic references to the dynamism of city life and to the ways in which all aspects of the city dwarfed human aspirations. It was the site itself, the streets of the city, that dominated; man seems insignificant, a minor player, on the larger stage of existence. It is a final statement about the way in which the urban scene, to some artists, overwhelmed the lives of those existing in its spaces.

In 1900, with the construction of the gigantic Exposition Universelle, the entire world came to Paris; the city attracted millions of visitors. To transport visitors around the fair, a moving walkway was constructed and an underground rapid transit system opened, with the elaborate gateways designed by Hector Guimard that invited people into the underworld. Dedication to the concept of progress, to rapid change, to innovation in all fields of endeavor became the goal of many. What became evident, though, was that something dramatic had changed. The happy, indolent hours spent in dreamy interludes in the parks of the city or in escapes to the countryside were altered by the continuous pace of

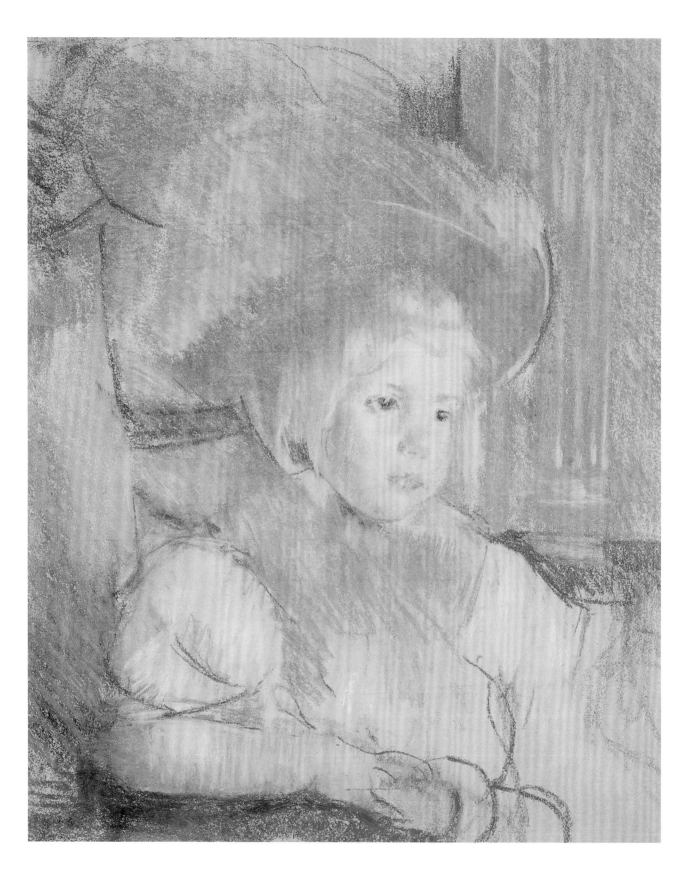

40. MARY CASSATT

Simone in a Plumed Hat, circa 1903

Pastel over counterproof, 24⅛ × 19⅝

Scott M. Black Collection

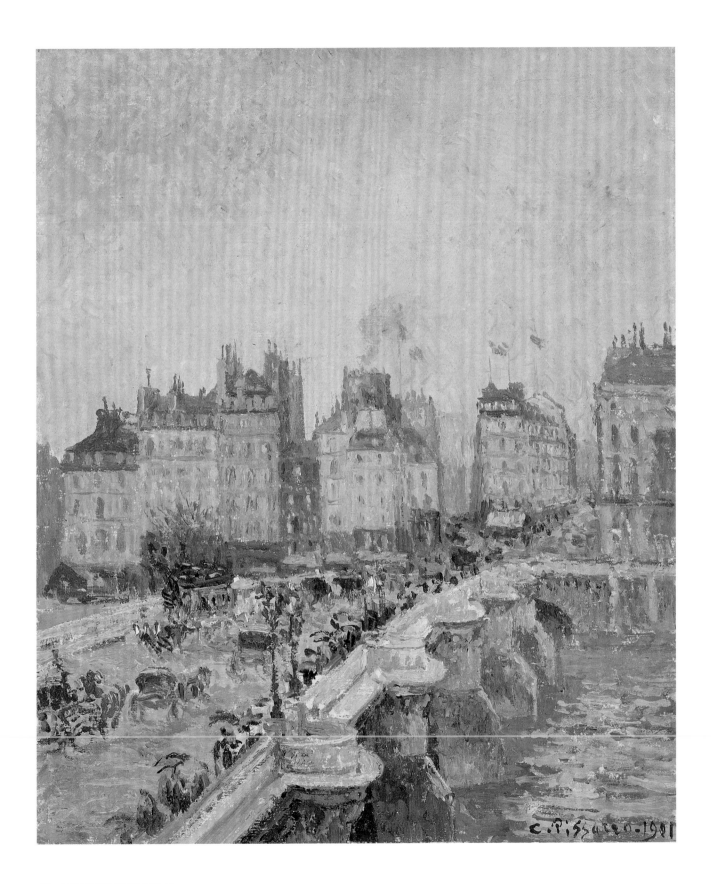

41. CAMILLE PISSARRO

Pont Neuf, Paris, 1901

Oil on canvas, $17\frac{3}{4} \times 14\frac{3}{4}$

Allen Memorial Art Museum, Oberlin College,
Ohio, R. T. Miller, Jr. Fund, 1941

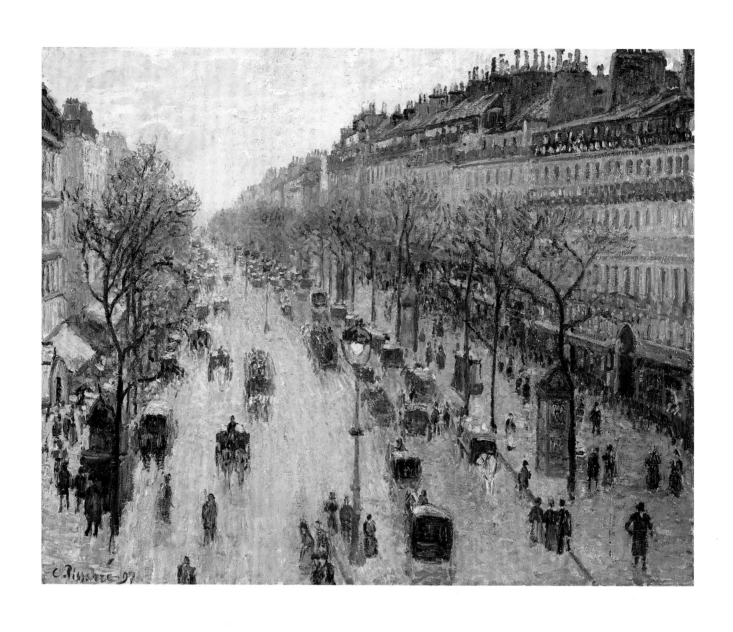

42. CAMILLE PISSARRO

The Boulevard Montmartre on a Winter Morning, 1897

Oil on canvas, 25½ × 32

The Metropolitan Museum of Art, Gift of Katrin S. Vietor,
in loving memory of Ernest G. Vietor, 1960, 60.174

urban existence; the noise, pollution, and energy of the city dwarfed everything else, forcing people to keep up with the new dynamics or fall by the wayside. Those who had little ability to change fell further into poverty and misery; deprivation became rampant, and beggars appeared everywhere, despite all the good intentions of social reformers, charity agencies, or the government. Only a few artists examined this depressing side of urban life. Obliquely, by means of insinuation, perhaps, a few other artists understood what was happening as the city streets emphasized isolation at a time when materialism spun out of control and human values were not supported. The urban panorama, a field of constant contrasts, provides significant visual clues as to the real state of society, and the ways in which artists from all camps responded. The philosophy of the good life, as espoused by the leaders of the Third Republic, was only a hopeful vision. In reality, it was but a dream that remained unattainable for most.[48]

Notes

In preparation of this essay the author acknowledges the support and assistance provided by Yvonne Weisberg and Janet Whitmore.

1. Maurice Henri Amédée Biais worked for Julius Meier-Graefe at La Maison Moderne as decorative designer and poster maker, and with other firms that have not yet been discovered. He was born on December 30, 1872, at Corbeil (Seine-et-Oise), the son of Amédée Biais and Aglaé Eugénie Laure Cazalis. He died on April 15, 1926, in Gorbio (Alpes-Maritimes) of tuberculosis. On June 7, 1911, he married Jeanne Louise Beaudon, known as Jane Avril, in Jouy-en-Josas (Seine-et-Oise). For this information, see the records in the city halls of Corbeil, Jouy-en-Josas, and Gorbio. See also François Caradec, *Jane Avril, au Moulin Rouge avec Toulouse-Lautrec* (Paris: Librairie Fayard, 2001). On the new woman phenomenon, see Debora L. Silverman, *Art Nouveau in Fin-de-Siècle France: Politics, Psychology and Style* (Berkeley and Los Angeles: University of California Press, 1989), and, on the history of the end of the century, see Eugen Weber, *France: Fin-de-Siècle* (Cambridge, Mass.: Harvard University Press, 1986).

2. For Meier-Graefe, see Catherine Krahmer, "Meier-Graefe et les arts décoratifs, un rédacteur à deux têtes," in *Distanz und Aneignung. Relations entre la France et l'Allemagne, 1870–1945* (Berlin: Akademie Verlag, 2004), pp. 231–51.

3. For a discussion of Jules Adler's humanitarian concerns, which he shared with other Jewish painters, see Gabriel P. Weisberg, "Jewish Naturalist Painters: Understanding and Competing in the Mainstream," in *The Emergence of Jewish Artists in Nineteenth-Century Europe*, exh. cat. (New York: The Jewish Museum; London: Merrell Publishers Limited, 2001), pp. 143–51.

4. On Chahine's prints, see M. R. Tabanelli, *Edgar Chahine. Catalogue de l'oeuvre gravé* (Milan: Les Editions il Mercante di Stampe, 1977). Chahine's career is discussed in *Edgar Chahine, La Vie Parisienne*, exh. cat. (Washington, D.C.: Smithsonian Institution Traveling Exhibition Service, 1984). The latter publication focuses on the humanitarian themes that Chahine used in many of his early Naturalist paintings, most of which have not been located.

5. While the prints and drawings of Paul Blanc remain little known today, he was a force in Paris during the 1890s, when his dedication to the theme of the beggar was fashionable. For a discussion of Blanc's work, see Gabriel P. Weisberg, "Paul Blanc's Beggars: Mendicity as Metaphor," in *Second Impressions: Modern Prints and Printmakers Reconsidered*, ed. Clinton Adams (Albuquerque: The Tamarind Institute, 1996), pp. 13–25.

6. See Eunice Lipton, *Looking into Degas: Uneasy Images of Women and Modern Life* (Berkeley and Los Angeles: University of California Press, 1987).

7. Louis Legrand was one of the artists whose works expanded the boundaries of what was considered appropriate, in sexual terms, to reproduce in drawings and prints. *Le Mâle* (*The Male*), a scene of rape, exists as an etching and a drawing; the latter was recently on the Paris market, when the author was able to study it. For further information, see Camille Mauclair, *Louis Legrand, peintre et graveur* (Paris: H. Floury et Pellet, 1910), p. 184. Similar to Émile Friant, Legrand studied female passions and emotions in works illustrating episodes from the life of cafés, ballet performances, and bars.

8. On the laundress as an icon, see Eunice Lipton, "The Laundress in Late Nineteenth-Century French Culture: Imagery, Ideology and Edgar Degas," *Art History* 3 (September 1980): 295–313.

9. Steinlen's place in society at the end of the nineteenth century has been the subject of recent studies. See Carolyne Krummenacker, Philippe Kaenel, and Raphael Gérard, *Théophile-Alexandre Steinlen (1859–1923)*, exh. cat. (Paris: Fragments Éditions, 2004).

10. See Phillip Dennis Cate and Susan Gill, *Théophile-Alexandre Steinlen* (Salt Lake City: Gibbs M. Smith, 1982), pp. 19–21.

11. On Steinlen's social commitment, see, for example, Donald Drew Egbert, *Social Radicalism and the Arts, Western Europe* (New York: Alfred A. Knopf, 1970), pp. 263–65. While this study is somewhat rudimentary as far as Steinlen is concerned, Egbert went far toward establishing a broader radical network of issues, ideas, and texts that informed the imagery of many artists.

12. On the number of cafés, see Theodore Zeldin, *France, 1848–1945* (Oxford: Oxford University Press, 1977), vol. 2, p. 699. By the end of the century, there were 27,000 cafés that, according to Zeldin, played an increasing role in the social life of the city. Also see W. Scott Haine, *The World of the Paris Café: Sociability among the French Working Class, 1789–1914* (Baltimore: Johns Hopkins University Press, 1996). Haine examines the café from a variety of aspects, seeing it as a site for increased political activism, a center of popular culture, and a product of the willingness of the working class to absorb alcohol to escape. For further information on cafés, also see Georges Bernier, *Paris Cafés: Their Role in the Birth of Modern Art*, exh. cat. (New York: Wildenstein, 1985). Undoubtedly, the role and impact of cafés in the visual arts are deserving of far more in-depth study than they have received, except for a few examples such as Le Chat Noir in Montmartre.

13. Zeldin, 1977, p. 699. Zeldin notes that cafés encouraged sociability. Also see Phillip Denis Cate, "Research, Pastels in Paris: From the Fin-de-siècle to the Belle Epoque," *Zimmerli Journal*, no. 2 (Fall 2004): 173–75.

14. Examination of Toulouse-Lautrec's relationship with many performers is both mysterious and in its infancy, including his relationship with Avril. Mention of Toulouse-Lautrec and Avril is found in Julia Frey, "Henri de Toulouse-Lautrec: A Biography of the Artist," in *Henri de Toulouse-Lautrec: Images of the 1890s*, ed. Riva Castleman and Wolfgang Wittrock, exh. cat. (New York: The Museum of Modern Art, 1985), pp. 19–35. Also see Frey, *Toulouse-Lautrec: A Life* (New York: Viking, 1994), pp. 333, 349, 379.

15. Caradec, 2001, writes that Avril found herself at age fifteen at the Salpêtrière Hospital in the clinic run by Dr. Jean Martin Charcot. It was a clinic established for solving the issues caused by all aspects of nervous disorders.

16. Frey, 1994, p. 349.

17. On the movement, see Phillip Dennis Cate and Sinclair Hamilton Hitchings, *The Color Revolution: Color Lithography in France, 1890–1900*, exh. cat. (Salt Lake City: Peregrine Smith; New Brunswick, N.J.: Rutgers University, 1978).

18. Castleman and Wittrock, 1985, pp. 240–41, where a preliminary drawing for the May Milton lithograph is compared with the finished print.

19. Frey, 1994, p. 184.

20. Frey, 1994, p. 398.

21. Frey, 1994, p. 422.

22. The memoirs of Jane Avril, which were published serially in 1933 in *Paris Midi*, are often fabricated episodes combined with truthful remembrances. Since they are the only available reference on Avril's life, outside of Caradec's study, which relied heavily on them, much of what we know about her remains conjectural. A listing of the performances she gave in the cabarets in Montmartre can be partially reconstructed from the published references in Parisian newspapers at the time.

23. Frey, 1994, pp. 354–55. On Marey, see Marta Braun, *Picturing Time: The Work of Etienne-Jules Marey (1830–1904)* (Chicago: University of Chicago Press, 1992).

24. Cléo de Mérode, *Le Ballet de ma vie*, preface by Françoise Ducout (Paris: Pierre Horay, 1985). This publication is filled with valuable period photographs, many of de Mérode herself, that attest to her beauty. Also see Raoul Ponchon, *La Muse gaillarde* (Paris: Fasquelle Éditeurs, n.d.), pp. 89–91.

25. By 1900 Cléo de Mérode was seen everywhere in Paris. See further "Numéro spécial: Cléo de Mérode de l'Opéra," *La Grande Vie*, no. 15 (1900). This issue was dedicated entirely to her. Also see *Un Siècle d'élégance française* (Paris: Les Éditions du Chêne, 1943), which contains evocative photographs of the dancer-model.

26. Richard Thomson, *The Troubled Republic: Visual Culture and Social Debate in France, 1889–1900* (New Haven: Yale University Press, 2005).

27. On the atmosphere of instability, see Jill Miller, "Propaganda and Utopianism: The Family and Visual Culture in Early Third Republic France (1871–1905)" (Ph.D. diss., University of Minnesota, 1998), specifically chapters 1 and 2 with an emphasis on the state of fear and regeneration philosophy.

28. For Prouvé and decorative mural painting, see Gabriel P. Weisberg, "Peinture décorative: la rencontre du symbole et du style; à travers les oeuvres d'Albert Besnard et Victor Prouvé," in *L'École de Nancy et les arts décoratifs en Europe* (Nancy: Éditions Serpenoises, 2000), pp. 60–75.

29. Gabriel P. Weisberg, *The Independent Critic: Philippe Burty and the Visual Arts of Mid-Nineteenth Century France* (New York: Peter Lang, 1993).

30. About Lefebvre and the Académie Julian, see Gabriel P. Weisberg, "The Women of the Académie Julian: The Power of Professional Emulation," in *Overcoming All Obstacles: The Women of the Académie Julian*, exh. cat. (New York: The Dahesh Museum; New Brunswick, N.J.: Rutgers University Press, 1999), pp. 12–67.

31. Armond Fields, *Henri Rivière* (Salt Lake City: Gibbs M. Smith, 1983). Also see Henri Rivière, *Les Trente-six vues de la Tour Eiffel* (Paris: Eugène Verneau, 1902).

32. Fields, 1983; and Rivière, 1902. Also see *Japonisme: The Japanese Influence on French Art, 1854–1910*, exh. cat. (Cleveland: The Cleveland Museum of Art, 1975).

33. Sharon L. Hirsh, *Symbolism and Modern Urban Society* (Cambridge: Cambridge University Press, 2004), pp. 50ff., specifically the discussion on Symbolist sociology.

34. Michael Wentworth, *James Tissot* (Oxford: Oxford University Press, 1984), pp. 164–65. Wentworth correctly notes the inexpressive, almost passive, expressions on the faces of the women painted by Tissot throughout the series.

35. For further reference to the range of Béraud's imagery, see Patrick Offenstadt, *Jean Béraud, 1849–1935: La Belle Époque, une époque rêvée; Catalogue raisonné* (Cologne: Benedikt Taschen Verlag and the Wildenstein Institute, 1999).

36. On the spread of leisure activities throughout the Third Republic as pictured by the Impressionists, see Robert L. Herbert, *Impressionism: Art, Leisure and Parisian Society* (New Haven: Yale University Press, 1988).

37. See *A Day in the Country: Impressionism and the French Landscape*, exh. cat. (Los Angeles: Los Angeles County Museum of Art, 1984). For a detailed examination of the specific works shown in each Impressionist show, see *The New Painting: Impressionism, 1874–1886*, exh. cat. (San Francisco: The Fine Arts Museums of San Francisco, 1986); and Ruth Berson, *The New Painting: Impressionism, 1874–1886; Documentation*, vol. 2, *Exhibited Works* (San Francisco: Fine Arts Museums of San Francisco, 1996).

38. See Herbert, 1988, for a discussion of a large number of themes that engaged the Impressionists. However, examination of the works of Raffaëlli, one of the more socially engaged Impressionists, still awaits a detailed study that will culminate in a widely accessible publication. For further discussion of Raffaëlli, see Barbara Schinman Fields, "Jean-François Raffaelli, 1850–1924: The Naturalist Artist" (Ph.D. diss., Columbia University, 1978). Fields's research for her dissertation has yet to be surpassed.

39. *Gustave Caillebotte: Urban Impressionist*, exh. cat. (Chicago: The Art Institute of Chicago, 1995). The essays in this publication moved the discourse of Impressionism toward a deeper examination of the impact of the urban environ-

ment on Caillebotte and, by implication, on other painters of the Third Republic, still awaiting further study.

40. *Caillebotte*, 1995. The examination of streets and city spaces in the catalogue advanced this type of discussion. More awaits study, especially with regard to a sociological evaluation of the impact of the urban environment on people.

41. On Edgar Degas, see *Degas*, exh. cat. (New York: The Metropolitan Museum of Art, 1988). This very detailed study of the works of Degas examines issues of his work throughout his lengthy career, including works completed after the end of the Impressionist exhibitions.

42. Offenstadt, 1999, p. 251, no. 329. The theme involved prostitutes who failed to register with the police.

43. Early accounts of Degas's ties with the Valpinçon family are discussed in Henri Loyrette, *Degas* (Paris: Librairie Arthème Fayard, 1991), pp. 196–98.

44. Barbara Ehrlich White, *Renoir: His Life, Art and Letters* (New York: Harry N. Abrams, 1984), p. 51. Also see *Renoir*, exh. cat. (London: Arts Council of Great Britain, 1985), for other paintings by Renoir that examine similar themes.

45. White, 1984. See also John House, *Impressionism: Paint and Politics* (New Haven: Yale University Press, 2004).

46. Nancy Mowll Mathews, *Mary Cassatt* (New York: Harry N. Abrams, 1987).

47. See *Pissarro*, exh. cat. (London: Arts Council of Great Britain, 1980), which examines some of the late street scenes, but well within the context of the Impressionist canon and interest in light and atmosphere. Other publications slight the late work almost entirely.

48. Weisberg, 2000; and Gabriel P. Weisberg, "Victor Prouvés Wandgemälde «La Vie» als soziale Kunst," in *Jenseits der Grenzen. Französische und deutsche Kunst vom Ancien Régime bis zur Gegenwart*, vol. 2, *Kunst der Nationen* (Cologne: DuMont Buchverlag, 2000), pp. 269–78.

French Landscape Painting and Modern Life

Jennifer L. Shaw

THE NINETEENTH CENTURY was characterized by the perception that the tempo of life had accelerated. In France, as in much of Europe, incessant change now seemed to be the norm. The political upheaval of the French Revolution, innovations in empirical science and the Industrial Revolution, the mass production of goods, the rise of capitalism, new faster modes of communication and transportation—all of these led to a sense that old certainties were unraveling when confronted with the fast pace of contemporary life.[1] This experience of modernity stood in marked contrast to a past that was imagined to have been cyclical, predictable, and steeped in tradition. One of the most eloquent formulations of the experience of modernity came from Karl Marx:

> Constant revolutionizing of production, uninterrupted disturbance of all social conditions, everlasting uncertainty and agitation distinguish the bourgeois epoch from earlier ones. All fixed, fast-frozen relations, with their train of venerable prejudices and opinions are swept away, all new-formed ones become antiquated before they can ossify. All that is solid melts into air, all that is holy is profaned, and man is at last compelled to face with sober senses, his real conditions of life, and his relations with his kind.[2]

Marx's description highlights the results of living in a constantly changing social, cultural, and economic landscape: a destabilizing sense of a new consciousness about contemporary life and social relations.

The experience of modernity had equally shattering effects in the arts. The French poet Charles Baudelaire famously called for a "painter of modern life" who would capture the most significant characteristics of contemporary life in his art. Said Baudelaire: "I mean by 'modernity' the ephemeral, the fugitive, the contingent, the half of art whose other half is the eternal and the immutable. . . . This transitory, fugitive element, whose metamorphoses are so rapid, must on no account be despised or dispensed with."[3] By the middle of

the nineteenth century, Paris was widely recognized as the quintessential modern European city. However, Baudelaire's essay also implied a more general model of art that could easily be applied to landscape painting.

Baudelaire suggested the necessity of depicting contemporary imagery in a manner that captured those sensations of the "ephemeral" and "fugitive" that defined modernity. To do so would require the artist to abandon old-fashioned subjects drawn from mythology and history, as well as centuries-old ways of making art taught by the government-sponsored art schools and favored by the French Academy. Instead, the artist should take a fresh approach to the real world, relying on his own senses rather than the learned concepts that had dominated traditional art. The best artists were those who had particularly strong sensibilities. This meant that they were especially sensitive both to the sensations presented to them by modern life and to their own feelings about their perceptions. To explain this idea, Baudelaire compared the modern artist to a "convalescent" and a "child":

> The convalescent, like the child, is possessed in the highest degree of the faculty of keenly interesting himself in things, be they apparently the most trivial. . . . The child sees everything in a state of newness; he is always *drunk*. Nothing more resembles inspiration than the delight with which a child absorbs form and color.

In this passage, Baudelaire suggests that the experience of modernity can best be expressed by the artist who, like a child, "sees everything in a state of newness." If, in the child, "Sensibility is almost the whole being," the artist has the ability to harness that heightened awareness of his own perceptions for the purposes of his art:

> The man of genius has sound nerves, while those of the child are weak. With the one, Reason has taken up a considerable position. With the other, Sensibility is almost the whole being. But genius is nothing more nor less than *childhood recovered* at will—a childhood now equipped for self-expression with manhood's capacities and a power of analysis which enables it to order the mass of raw material which it has involuntarily accumulated.[4]

According to Baudelaire, the modern artist will combine the "ecstatic gaze" of the child with a "power of analysis" to order his sensory perceptions and his feelings about sensation into a convincing visual form. Significantly, Baudelaire attributed this power of analysis to "the man of genius" who "has sound nerves." Women were deemed to have "weak" nerves, much like children. Baudelaire imagined the ideal modern artist as a man with an especially

heightened sensibility that would be given form in the images he produced. In the works of the Impressionists, this privileged sensibility was often expressed as an interaction between the artist and the scenes of modern life—be they in the urban center or in the landscapes of modern life now easily accessible by train.

Many of the works represented in *Paris and the Countryside* answer Baudelaire's call for a new form of art representing the "things" of modern life, "be they apparently the most trivial." What is more, in their landscape paintings artists used techniques that emphasized sensibility over and above traditional aesthetic conventions. There was a strong sense among independent artists and the critics who supported them that contemporary life had transformed the way people apprehended the world. Established approaches to painting could not adequately address the responses of people living under the conditions of modernity. Certain artists—those with privileged sensibilities—might be able to capture something important about contemporary life in their works as long as they left aside the approaches to art promoted by the French Academy. One way of thinking about the experiments that took place in the avant-garde painting of the late nineteenth century is to see them as a series of attempts to devise alternatives to academic painting that would not only offer images of the contemporary world but, equally important, be more fitting embodiments of the modern sensibility. I want to explore the imagery of the modern landscape, but I also want to examine how, even in works that eschew overt imagery of modernity, the concepts of sensibility and sensation might still be related to modern life. The notion of modern perceptions related to the experience of modern life was central not only to Impressionism but also to the Neo-Impressionists and the Nabis, whose works are represented in *Paris and the Countryside*.

IMPRESSIONS, SENSATIONS, AND LANDSCAPE PAINTING

> Once the impression is captured, they declare their role terminated. . . .
> If one wants to characterize them with a single word that explains their
> efforts, one would have to create the new term *Impressionists*. They are
> impressionists in the sense that they render not a landscape but the
> sensation produced by the landscape.[5]

In 1874 Jules-Antoine Castagnary wrote this famous response to what we now call the first Impressionist exhibition. He suggested as an appropriate name for the painters exhibiting there "Impressionists" and defined what he meant by that term: "they render not a landscape but the sensation produced by the landscape." As Castagnary's definition suggests, Impressionist painting was an attempt to register in paint the sensations that modern life left on the sensibilities of artists. In some cases, emblems of the modern, such as factories or train

tracks, are integrated into Impressionist paintings. However, to be a modern painter one did not necessarily need to picture modern life, but one did have to paint in a way that reflected the feelings resulting from the experience of modernity. Even when it did not depict modern life, Castagnary suggests, Impressionist landscape painting encoded the artist's immediate perceptions overtly in its "technique of execution" and its "material means," and by virtue of that emphasis on sensation was deemed Impressionist. Another critic who helped define Impressionism, Edmond Duranty, described Impressionism as a "new painting" that "tries to capture life and the modern spirit, an art that reacts viscerally to the spectacle of reality and contemporary life."[6] Again we see the overlapping of the imagery of modern life and the sensibility of the artist who "reacts viscerally" and records that reaction in paint. These artists, said Duranty, offered an alternative to a tradition "in disarray," "wholly modern art, an art imbued with our surroundings, our sentiments and the things of our age."[7]

Why was *Impressionism* such an apt term for paintings like those in *Paris and the Countryside* by Claude Monet, Armand Guillaumin, Alfred Sisley, and Camille Pissarro? In colloquial language, the term *impression* has several valences. On the one hand, it can designate a literal trace, as when footsteps across a beach leave impressions in the sand. This sense of an impression as a trace suggests an objective, even physical, record of something that has been present. On the other hand, *impression* is often used to describe a reaction to an event that is filtered through an individual's sensibility, as when one says, "I had the impression that she was angry with me." The term thus encompasses notions of both objective trace and subjective reaction.[8] These two meanings are evident in the way Impressionist painting was interpreted in the nineteenth century. Not only Castagnary and Duranty but Émile Zola as well interpreted the "new painting" in this way. Zola's famous description of art as "nature seen through a temperament" embeds both the importance of recording the objective world ("nature") and imbuing that recorded image with the artist's individual sensibility ("temperament").

The term *impression* also had a specific meaning with relation to painting. It was one of several terms to describe a painting that had the status of an unfinished sketch.[9] Monet used the term for the title of a painting of the port of Le Havre he included in the first exhibition organized by the artists we now call the Impressionists, seemingly uncomfortable exhibiting this work without announcing to his viewers it was only an "impression" (sketch), not a finished tableau. *Impression, Sunrise* (Fig. 43) prompted Louis Leroy, writing for the satirical magazine *Le Charivari*, to emphasize the sketch quality of the painting: "Wallpaper in its embryonic state is more finished than that seascape," he scoffed.[10] Monet's title seems to have led critics like Castagnary and Leroy to describe the whole group of artists in the exhibition as "Impressionists."

If we are to understand the link between Impressionism and sensation, it will be important to understand the precise meaning of the word *impression* in the sketch vocabulary of the nineteenth century. An *impression* was a particular kind of sketch. It represented the artist's attempt quickly to record the objective qualities of a real landscape or the atmosphere of light at a precise moment as they struck his individual sensibility. Thus, when an artist used the term *impression*, he meant that his painting was a record of his perceptions of the landscape. This practice of sketching in the open air (*en plein air*), on the spot, had a long history. Landscape painters in the seventeenth century had gone into the countryside to note their "impressions," though their plein-air works were usually done in ink on paper. In the nineteenth century, partly because of the new portability of paints in tubes, rather than in animal bladders, landscape painters were able to take their oils outside and sketch in colors. These "impressions" were records of the artist's experience in front of the motif. Such works became an archive of recorded sensations on which the artists could draw when they went back to their studios to work up a fully finished tableau. The

43. CLAUDE MONET

Impression: Sunrise, Le Havre, 1872

Oil on canvas, 19 × 24⅜

Musée Marmottan, Paris, France

44. CLAUDE LORRAIN

Landscape with the Marriage of Isaac and Rebekah (The Mill), 1648

Oil on canvas, 60 × 79

The National Gallery, London

final, finished painting, while based on the sketches, ultimately submitted the particularities of the artist's experience to the traditional conventions of landscape painting.

Many of the landscapes shown at the public art exhibitions organized by the French state in the nineteenth century, called the Salon, still held to the rules of academic landscape painting established in the seventeenth century by such artists as Claude Lorrain (Fig. 44) and Nicolas Poussin. These were idealized images of nature, picturing timeless settings, usually set in an imagined classical past, often framed by rocks or trees, with central elements leading the viewer's eye gently back into the distance. Often the foreground was peopled with historical figures, shepherds, or nymphs, who served as points of identification for the viewers as they took an imaginary trip through the perfected landscape. The surfaces of these paintings were highly finished, the compositions tightly structured. In short, they stand in great contrast to the flat, loosely painted slices of life we see in Impressionist landscapes.

Camille Corot bridges the divide between the Impressionists and classical academic landscapists such as Claude Lorrain. Corot exhibited many highly finished and idealized landscape tableaux at the Salon exhibitions in Paris.

However, he also valued the individual sensibility represented by *impressions*. Corot used the term *impression* when describing his practice, and he associated it with sketching in the landscape. In an entry in his notebook from about 1855 he wrote: "The beautiful in art is truth, filtered through the impressions we receive as we see nature. . . . Reality is a part of art, but it is feeling which makes it whole."[11] In 1826 he sketched his impression of *The Bridge at Narni* (Fig. 45). This sketch, done on a small scale (only 13⅜ by 18⅞ inches) with oil paints on paper, was the basis for a much larger, fully finished tableau that he exhibited at the Salon of 1827 (Fig. 46). In the sketch, we see ample evidence of Corot's presence while sketching on the spot. The painting is made up of

45. JEAN-BAPTISTE-CAMILLE
COROT

Le Pont de Narni
(*The Bridge at Narni*), 1826

Oil on paper on canvas
13⅜ × 18⅞

Louvre, Paris, France
R. F. 1613

46. JEAN-BAPTISTE-CAMILLE
COROT

Le Pont de Narni
(*The Bridge at Narni*), 1827

Oil on canvas
26¾ × 37¼

National Gallery of Canada,
Ottawa, no. 4526

alternating areas of greens and various shades of beige, which lay out the struc-
ture of the landscape in a loose patchwork. In the foreground, the land is indi-
cated in a way that suggests it falls precipitously away below us, and the far
distance is blocked by the remnants of the bridge and the mountains that rise
above the horizon. Looking at the finished tableau, we see that the trace of the
artist's experience in the landscape found in the sketch is subsumed by the con-
ventions of classical landscape painting. The foreground has been flattened,
and a road peopled by figures invites the viewer into the painting. The space is
framed by trees and rocks. The river gently leads the eye into the distance. And,
significantly, any sense of the brushwork as a record of a specific moment in a
particular spot has been replaced by a technically masterful gradation of tone
and color with no sign of the artist's hand remaining.

In his later work, Corot moved away from the classical landscape to evoca-
tions of his home territory in the French countryside and the Forest of
Fontainebleau near the town of Barbizon. He is thus categorized as part of the
Barbizon school of artists—including Théodore Rousseau and Charles-François
Daubigny—who in the mid-nineteenth century focused on the wilder aspects of
the forest. These artists, and many others, emphasized the natural landscape to
the exclusion of all signs of contemporary life. Very often their work depicted
figures dwarfed by natural features unspoiled by man. Signs of human presence
usually took the form of churches or cottages, which had a timeless quality. The
examples of Corot and the Barbizon school suggest that the "impression" and
the emphasis on sensibility had long played a part in French landscape painting.

However, a few important points of difference can help us define the
Impressionist project. First, the willingness on the part of artists like Monet,
Pissarro, Guillaumin, and Sisley to integrate overt signs of modernity into
their landscapes separates them from their immediate predecessors. Second,
unlike Corot, who always maintained the distinction between the *impression* and
the tableau, the artists we now know as Impressionists abandoned large, fin-
ished pictures early on. From the late 1860s their work focused solely on the
sketch and its emphasis on sensation. Significantly, by midcentury landscape
painting that emphasized "temperament" had become extremely popular with
the public. While sketches emphasizing sensibility had been valued by artists
and connoisseurs for more than a century, a new speculative market for land-
scape sketches emerged in the mid-nineteenth century. This was connected
to efforts by art dealers, "experts," and auction houses to promote higher
prices for the sale of sketches and other works found in the studios of recently
deceased painters who in their lifetimes would never have exhibited such
work. This speculative market in landscape painting contributed to a new
sense that individual temperament was the most important characteristic in
art.[12] The painters associated with Impressionism capitalized on this vogue for
the sketch.

The impressionists work . . . to convey the very first aspect of visual sensation, without allowing the understanding to lead it astray with the male science of the eye, or to complicate it with hypothetical traits; to learn to see, but to see exclusively the initial appearance of things; to conserve such a vision and fix it; such is the goal of these analytic painters.[13]

In his review of the final Impressionist exhibition in 1886, Paul Adam emphasized the importance of the initial sensation. He suggested that the painters were seeing afresh, answering Baudelaire's call for an artist who sees "like a child." Significantly, Adam refers to "the male science of the eye" as one of the major ideas that might "allow understanding to lead [painting] astray." With this phrase, Adam referred to the academic theories that dominated aesthetic education in the second half of the nineteenth century, in particular Charles Blanc's seminal text *The Grammar of Painting and Engraving*, which had become a handbook for artists during this period. Blanc's text was an important resource for many of the painters represented in *Paris and the Countryside* because, despite propounding old-fashioned views about many aspects of painting theory and technique, it also discussed recent scientific research into color and its application to painting. Blanc argued that, unlike drawing, "whose absolute principles cannot be taught," color is subject to "fixed laws," analogous to those in music. He drew on Sir Isaac Newton's analyses of the solar spectrum to define the "simple" colors—red, yellow, and blue—and the "composite" colors—violet, green, and orange—as well as the "complementary" relations between simple and composite colors: "We call *complementary* each of the three primitive colors, with reference to the binary color that corresponds to it. Thus blue is the complement of orange because orange being composed of yellow and red, contains the necessary elements to constitute white light. For the same reason, yellow is the complement of violet, and red of green." Furthermore, Blanc instructed his readers about the "law of complementary colors":

If we combine two of the primary colors, yellow and blue, for instance, to compose a binary color, *green*, this binary color will reach its maximum intensity if we place it near its complement—*red*. So, if we combine yellow and red to form *orange*, this binary color will be heightened by the neighborhood of *blue*. Finally, if we combine red and blue to form *violet*, this color will be heightened by the immediate neighborhood of *yellow*. Reciprocally, the red placed beside the green will seem redder; the orange will heighten the blue, and the violet will heighten the yellow. It is the reciprocal heightening of complementary colors in juxtaposition that M. Chevreul called "*The law of simultaneous contrasts of colors.*"[14]

Blanc also discussed the theory of optical mixture, the notion that, when seen from a distance, two colors placed side by side will "form a third color."[15] Finally, he instructed artists about the effect of the color of light, which can be influenced by factors such as atmosphere, weather, or geographic location. Southern light, he said, looks quite different from "the cold light of the north," whose blue is "heightened in the light, attenuated in the shade."[16] We can see these theories of color taken up explicitly in many of the paintings represented in this exhibition. One early example is Armand Guillaumin's *La Plaine de Baigneaux* from 1874 (Fig. 47). Here, Guillaumin pictures a modern subject: the borderlands between the city of Paris, seen in the distance, and the countryside immediately surrounding the expanding city. Figures leaving the city on foot and in a carriage traverse one of two primitive roads that divide the composition. Each of these paths is defined by a juxtaposition of the complementary colors blue and orange placed side by side. This blue-orange combination is repeated in the rooftops of the vaguely indicated outskirts of the city in the far distance.

While painters who desired to be modern embraced Blanc's scientific description of color, they rejected the more traditional aspects of his text. For example, Blanc maintained the distinction between the linear aspect of drawing and color that had dominated Renaissance and Baroque debates about the arts. Blanc stated that drawing and chiaroscuro (the distribution of light and shade used by painters to define three-dimensional form) "put in relief all that depends on intelligent life," while "color is *par excellence* the means of expression, when we would paint the sensations given us by inorganic matter and the sentiments awakened in the mind thereby."[17] Drawing was thus imagined as a product of intellect and hence addressed the mind, whereas color derived from the material world and could only address feelings. Blanc viewed these divisions between drawing and color, intellect and sensation, in gendered terms: "drawing is the masculine side of art, color the feminine."[18] When Adam said the Impressionists "convey the very first aspect of visual sensation, without allowing the understanding to lead it astray with the male science of the eye," he was suggesting that the Impressionists were trying not to let intellectual ideas get in the way of the brute transcription of their perceptions. But as Blanc's text shows, sensation was widely associated with color. To sketch on the spot, with the aim of recording visual stimuli rather than transforming the landscape according to a preconceived idea, was to elevate the significance of sensation by embracing color as the primary structuring principle of painting. This went directly against the advice given by Blanc in his handbook of academic theory, which emphasized the predominance of "the male science of the eye":

> Above all let the colorist choose in the harmonies of color those that seem to *conform to his thought*. The predominance of color at the expense

47. JEAN-BAPTISTE-ARMAND GUILLAUMIN

La Plaine de Bagneux, au sud de Paris
(*The Plain of Bagneux, South of Paris*), 1874

Oil on canvas, 25¼ × 30

Private collection. Courtesy of Wildenstein &
Co., Inc., New York

of drawing is a usurpation of the relative over the absolute, the fleeting appearance over permanent form, of physical impression over the empire of the soul. As literature tends to its decadence, when images are elevated above ideas, so art grows material and inevitably declines when the mind that draws is conquered by the sensation that colors.[19]

Blanc warned that color should not take precedence over drawing. Color and sensation that were not kept in check threatened art with materialism and decadence. While the painters represented in *Paris and the Countryside* were able to make use of many of the "rules" of color described by Blanc, they clearly disregarded the advice he gave about the proper role of color. Unlike Corot, who ultimately, in his finished pictures, made his compositions "conform to his thought," bringing color under the idealizing control of drawing, the Impressionists emphasized the relative over the absolute. Their work was characterized by an attempt to record the sensation of the landscape in the open air using color, which was associated with "the fleeting appearance," and they dispensed with "permanent form." In doing so, they pursued a kind of art that went against the traditional rules of art derived from Raphael and Poussin in favor of work that embraced modernity as Baudelaire had defined it: "the ephemeral, the fugitive, the contingent, the half of art whose other half is the eternal and the immutable" (Fig. 48).

THE RAILROAD, TOURISM, AND THE MODERNIZATION
OF THE COUNTRYSIDE

Many of the works in this exhibition integrate overt signs of modern life into the landscape. These emblems of modernity range from signs of industrialization to images of leisure, in addition to scenes of the shifting border region of the ever-growing city of Paris. The Industrial Revolution brought about new forms of transportation, which fundamentally changed the relationship between people and the landscape. The first railroad lines in France were built in the 1830s. By the end of the nineteenth century trains traversed more than fifteen thousand miles of track that linked far-flung regions of France with each other and with other parts of Europe. The vast network of railroads also played into the French government's attempt to strengthen national identity in the wake of the Franco-Prussian War (1870–71). The notion that regional sites were the heritage of all French citizens was promoted through tourism. Guidebooks illustrated with tourist views and geared toward travel by rail became abundant.

The railroads shifted perceptions of distance. Places that had been far away and inaccessible now were available with a short train journey. This, combined with the increased leisure time afforded by new modes of the production of goods, resulted in the colonization of once rural landscapes by day-trippers from urban centers. In addition, the experience of train travel began to define

48. CLAUDE MONET

The Seine at Bougival, 1869

Oil on canvas, 25 ¾ × 36 ⅜

Currier Museum of Art, Museum Purchase,
Currier Funds, 1949.1

the visual perception of the countryside. The details of the landscape that had previously been visible when walking or traveling by carriage were now erased in favor of an overall perception of a landscape defined by generalized shapes and colors. In a letter dated 1837, the writer Victor Hugo described his view from the car of a moving train: "The flowers by the side of the road are no longer flowers but flecks, or rather streaks, of red or white; there are no longer any points, everything becomes a streak; the grainfields are great shocks of yellow hair; fields of alfalfa, long green tresses."[20] The visual impressions of the landscape appeared fleeting and took their most pressing form as colors juxtaposed with one another rather than as clearly defined forms.

Once the railroad lines were in place, villages not far from Paris were transformed from elements of the countryside into something more like what we now call suburbs. However, because they still maintained some aspects of their rural characteristics, these villages close to Paris made it possible for people with only a little leisure time (or inadequate funds for a long trip) to enjoy an escape from the city and to imagine that they were gleaning the beneficial effects of a country retreat. In the 1870s the village of Argenteuil was a favorite site for Impressionist painters. Earlier in the century, Argenteuil, on the river Seine, less than seven miles from the center of Paris, had become industrialized; factories and iron bridges became part of the landscape. In 1851 the first railway service was established and Argenteuil was transformed from a rural agricultural village to a popular resort. Eating and lodging establishments began to cater to the tourist trade. Parisians traveled there by steamboat or a twenty-two-minute train ride, to stroll along the banks of the river. Boating and sailing were also very popular. The traffic on the water was busy, including sailboats, steamships, barges, and rowboats.

In early 1871 Monet moved to Argenteuil and stayed until 1878.[21] During this time he painted more than 170 canvases in the open air from the banks of the river as well as from a boat that he used as a floating studio. This allowed him to experiment with his sketch techniques, focusing particularly on the effects of light on water. Painting in Argenteuil, Monet was forced to decide whether to include the newly industrialized features of the landscape. *Springtime in Argenteuil* (Fig. 49), painted in 1872, is one of his earliest pictures of the locale. One of the striking aspects of this view of the Seine is what it leaves out. Monet has chosen a site that includes neither signs of industrialization nor the hustle and bustle of modern leisure, so that he could focus on pristine nature. The painting describes a small offshoot of the Seine. The only signs of human presence are the tiny marks in the central distance that indicate buildings in the town of Bezons. This painting shares much with the approach to sketching the landscape seen in the work of Monet's Barbizon predecessors. Not only is the subject a retreat from modernity, in that it shows unspoiled nature in the greening of spring, but the palette and brushwork also derive from the

49. CLAUDE MONET

Le Printemps à Argenteuil (Springtime in Argenteuil), 1872

Oil on canvas, 19½ × 25⅛

The Joan Whitney Payson Collection at the
Portland Museum of Art, Maine, Promised gift of
John Whitney Payson, 15.1991.6

traditional approach to sketching out of doors. The composition is almost classical in its structure, with a clearing in the foreground and the river leading the eye diagonally back into the distance. The horizon parallels the picture plane, and a screen of trees forms verticals that intersect the river and horizon. This careful structure gives the painting an effect of calm and stability that counterbalances the sketchy quality of the quick strokes of greens in the foreground. This image of Argenteuil is very different from many of Monet's other paintings of Argenteuil of the mid-1870s that highlight contemporary structures and leisure activities.[22] Monet depicted sailing regattas, the promenade along the river used for strolling, and even the new railroad bridge, which was built after the old one was destroyed by the Germans in 1870. *Springtime in Argenteuil* foretells a tendency on Monet's part, indulged in during the 1880s, to avoid overtly modern subject matter, leaving the technique of painting in the open air with heightened color and loose brushwork as the most important sign of the work's modernity.

In Armand Guillaumin's *The Arcueil Aqueduct at Sceaux Railroad Crossing* from circa 1874 (Fig. 50), which was exhibited in the 1877 Impressionist exhibition, the railroad's mark on the landscape was recorded directly.[23] Here Guillaumin, who began painting while he was employed by the Paris–Orléans railway, depicted the intersection of two newly built structures, the Paris–Sceaux railway line, running from the lower right corner of the painting, and the Aqueduc de la Vanne. The aqueduct was famous enough to be listed in many contemporary guidebooks as a landmark.[24] Once the railway line was constructed in the 1840s, it took only minutes to reach Arcueil from Paris. Arcueil, which had been a location for country houses of wealthy Parisians for some time, now became a tourist retreat. To the left of the railway line, figures are summarily indicated. Some of the women carry parasols and appear to be fashionably dressed. The painting thus not only integrates modern structures (the railway and the new aqueduct) into the landscape but also suggests the encroachment of urban Parisians on the nearby countryside. Guillaumin himself worked in Paris, having taken a night shift with the Department of Bridges and Roads that allowed him to paint during the day. In his leisure time, he traveled to the countryside around Paris to paint, much like tourists pursuing other activities.[25]

As he had in *La Plaine de Baigneaux*, Guillaumin used color contrasts to structure his composition. The painting is dominated by greens and oranges. The growth of plant life in between the railroad tracks is loosely indicated by dabs of green paint, which are highlighted with orange to indicate earth. Orange dabs of sunlight accent the trees growing in the grassy triangle in the middle foreground. The beige aqueduct itself is not a solid color but includes warm orange marks where the sun hits it. Cool green dabs infiltrate the beige in its shaded regions. These colors even carry through in the sky's puffy clouds.

Guillaumin, who exhibited in six of the eight Impressionist exhibitions, was a close friend of Paul Cézanne and Camille Pissarro. Like them, he

50. JEAN-BAPTISTE-ARMAND GUILLAUMIN

The Arcueil Aqueduct at Sceaux Railroad Crossing,
circa 1874

Oil on canvas, 20¼ × 25⅝

The Art Institute of Chicago, Restricted gift of
Mrs. Clive Runnells, 1970.95

approached the application of paint with an eye toward structure. However, the structure was suggested less by drawing than by a savvy and spontaneous application of contrasting colors. Guillaumin often sketched the composition in charcoal and then used pastels to determine the colors to be applied. Within these parameters, he was able to paint directly with his chosen colors.[26] As Corot had done in the sketch for *The Bridge at Narni*, Guillaumin has limited his palette and used patches of color to indicate the structure of the landscape as it appeared to him, on the spot, in the open air. Unlike Corot, though, Guillaumin chose a palette informed by modern theories of color, with the express intention of increasing the effect of light and color contrast. And this he did to great effect. The landscape appears flooded with an almost glaring light.

Monet's *Train at Jeufosse* (Fig. 51) shares with Guillaumin's canvas the imagery of the train and the interest in using patches of color to indicate the effects of light observed *en plein air*. However, there the similarities end. Where Guillaumin used color to give solidity to the depicted forms, Monet applied color to dissolve forms in a screen of colored brushstrokes. Monet integrated the train and its smoke into a continuum of color. In the nineteenth century, the train was imagined as a projectile cutting its way through the virgin landscape.[27] Nonetheless, in *The Train at Jeufosse*, which pictures a place near Giverny, Monet obfuscated any sense of speed or industrial structure, treating his viewers instead to a calm, pastel vision in which the puffs of yellow and orange smoke are the only hints that the bluish violet horizontal strokes beneath suggest a train.

Modern theories of color informed Monet's choices of pigment but in an informal and improvised way. Contrasts between violet and yellow are integrated at points with blues and oranges, reds and greens. The overall effect is peaceful and timeless, despite the presence of the train. Monet executed the painting in 1884 and seems to have kept it in his possession for several years. Ultimately, he gave this painting to the great Symbolist poet Stéphane Mallarmé, when Mallarmé and the Impressionist painter Berthe Morisot visited Monet in Giverny in the early 1890s. In a letter to Monet, Mallarmé wrote: "One does not disturb a man experiencing such joy as the contemplation of your painting brings me, dear Monet. My mental health benefits from being able to lose myself in this dazzling sight, at my leisure."[28] This letter speaks to the painting's positive vision of an unadulterated countryside. Mallarmé's reference to the benefits to his mental health reflects the nineteenth-century notion that visits to the country were considered healthful antidotes to urban modernity. In this case, landscape painting was imagined to offer another way of experiencing those same beneficial qualities, even once one had returned to the city. Indeed, Mallarmé suggests that Monet's painting does the natural landscape one better, offering a heightened "dazzling" view of the countryside's sensory possibilities while editing out any negative characteristics.

51. CLAUDE MONET

Le Train à Jeufosse (The Train at Jeufosse), 1884

Oil on canvas, 33⅜ × 39½

Private collection

Monet's near erasure of the train in the image of Jeufosse can be explained by a shift in his work that had begun several years earlier. In the late 1870s Monet had increasingly eschewed overt signs of modernity in his motifs. In an attempt to leave behind the constant reminders of modern life in Argenteuil, he moved from that village, which was right on the railway line, to the medieval village of Vétheuil, which was farther away from the nearest train station and forty miles from Paris on the river Seine. Across the river was the picturesque town of Lavacourt. In the late 1870s and early 1880s, Monet painted many images of the river and surrounding landscape, sometimes from the shore, sometimes from his studio boat.

Two paintings in *Paris and the Countryside*, *The Seine at Lavacourt* and *The Seine at Vétheuil* (Figs. 52 and 53), show Monet studying the landscape in different conditions of light and weather. Although the paintings share a similar subject—the reflections of the surrounding landscape in the water of the river Seine—Monet's approach to color and brushwork varies greatly from one painting to another. The palette of *The Seine at Lavacourt* is relatively naturalistic compared with the bright pinks, purples, oranges, and greens in *The Seine at Vétheuil.* The vibrant colors in the later work are accompanied by brushwork that is far looser and more experimental. The landscape in the background is composed of relatively thick strokes of greens, oranges, and blues arranged in diagonals and curves that vaguely define the rolling hills. These same colors are reflected in the water with shorter alternating horizontals. A similar effect is created in the trees and their reflections. The difference between objects and their reflections is connoted by the slight difference in paint application in the inverted images as well as by slight variations in color choice. Where the earlier picture suggests an artist using a relatively traditional sketch technique to render his optical sensations, the later image of Vétheuil points to experimentation with color and paint application. We know that the colors we are seeing cannot possibly be records of an optical experience faithfully rendered. Drawing on the idea of the "impression" as a work that expresses feeling, we are encouraged to attribute the extreme color to Monet's feelings and his own particular and identifiable sensibility. The work thus speaks of subjective experience as much as empirical, optical experience, and in this it presages the work of many Post-Impressionist artists.

The possibilities of traveling away from the city as a tourist on vacation expanded in the nineteenth century. By midcentury, tourism had taken off. Wealthy aristocrats now found it easier to escape the city by staying for extended periods at their large country estates. Edgar Degas's *Children and Ponies in a Park* (Fig. 54) depicts leisure of this kind. It was painted circa 1867 on the Valpinçon family's estate in Normandy, where Degas, a close friend, visited the family often. The painting probably depicts the Valpinçon children at play. Never exhibited publicly during Degas's lifetime, the painting appears to be a private record of a summer spent with intimates.

52. CLAUDE MONET

La Seine à Lavacourt (*The Seine at Lavacourt*), 1878

Oil on canvas, 22 ⅛ × 28 ⅞

Scott M. Black Collection

53. CLAUDE MONET

La Seine à Vétheuil (*The Seine at Vétheuil*),
circa 1880

Oil on canvas, 23 × 28¾

Portland Museum of Art, Maine,
Gift of Mrs. Stuart Symington, 1998.95

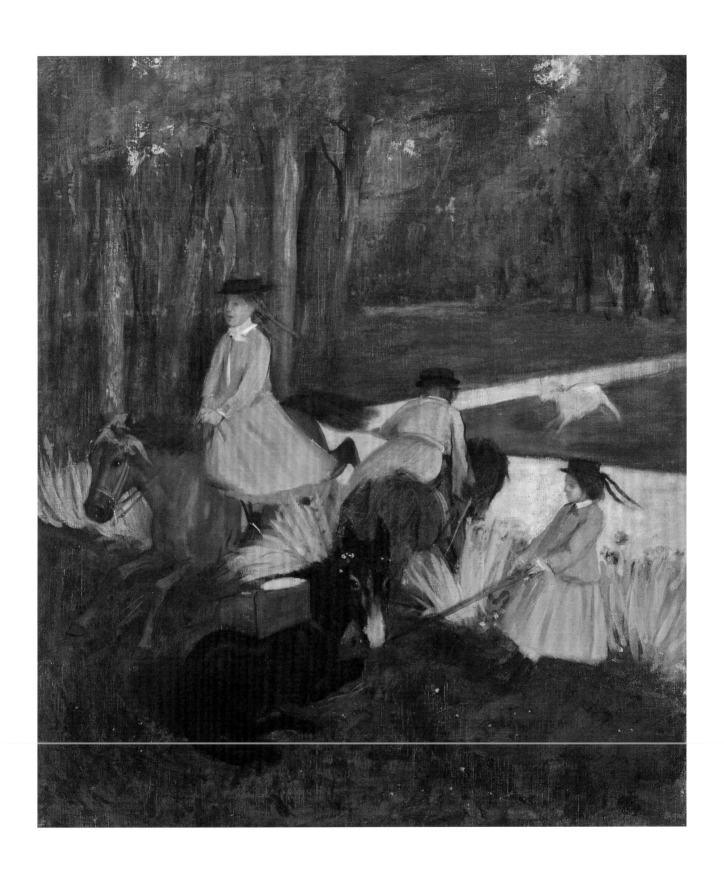

54. EDGAR DEGAS

Children and Ponies in a Park, circa 1867

Oil on canvas, 39 ¾ × 35 ³⁄₁₆

From the Joan Whitney Payson Collection

Toulouse-Lautrec's portrait of his father, le comte Alphonse de Toulouse-Lautrec, also attests to such leisure while offering a strangely compelling characterization. His father was a onetime career officer in the cavalry and a lifelong horseman, known for his jumping and steeplechase. The sketchy style in which the painting was executed seems to parallel the sitter's elusiveness and absence from the artist's life—an absence that was rationalized, moreover, as a desire to live in the country to pursue riding and hunting activities.

While the country retreat had long been a privilege of the very wealthy, the countryside became available to the middle and working classes in the nineteenth century due to ease of transportation and increased leisure time. Many of the bourgeoisie built more modest weekend retreats within a train ride of the capital. Even those who could not afford to keep country houses were able to take advantage of short vacation rentals or days out in the country. It has been estimated that by the middle of the nineteenth century the number of temporary visitors to the countryside almost matched the population of permanent residents.[29] Monet, Manet, Sisley, Renoir, and Pissarro all rented small country houses at one time or another.

In the 1880s Alfred Sisley lived in the town of Moret, a village not far from Paris, near the Forest of Fontainebleau that had so attracted the Barbizon school. In *Moret-sur-le-Loing* (Fig. 55) Sisley paints the river Loing with the village in the background. The composition is carefully structured with the foreground divided between river and riverbank, and the middle ground is dominated by the village and trees. At the left, tall trees anchor the foreground. Within this simple geometric structure, Sisley uses a typical Impressionist sketch technique. Large horizontal strokes of alternating blues and pale pinkish whites suggest ripples in the foreground. Farther back, reflections of the buildings in the water are indicated. In the left foreground, the vegetation is described with a variety of colors: small diagonal strokes suggest grass, long brownish strokes indicate tree trunks, and wispy green and purplish blue paint demarcate tree canopies. The sky is depicted with a variety of soft whites, pinks, and violets. The scene is peaceful, and though we are shown the town of Moret, no human presence disturbs the sense of balance between village and nature. In this painting, color becomes a sign of the sensibility of the artist. Sisley balances a degree of conventional color—the reddish brown roofs in the town, or green grass at the edge of the river—with color that is clearly heightened for effect. The deep blues and purples in the water are carried through in the leaves of the trees, which integrate touches of green, blue, and violet. Likewise, the dry grass in the foreground is made up of browns, reds, pinks, greens, and yellows.

In addition to villages close to Paris, towns on the coast of Normandy to the north and on the Mediterranean to the south became popular tourist spots for a range of vacationers. Louise Abbéma's *A Game of Croquet* (1872), Eugène Boudin's *Beach Scene near Trouville* (1886), and Gustave Caillebotte's *Regatta at Trouville* (1884) picture just this kind of fashionable resort by the sea (Figs. 56–58). Caillebotte's painting takes a distant view of Trouville, a popular resort

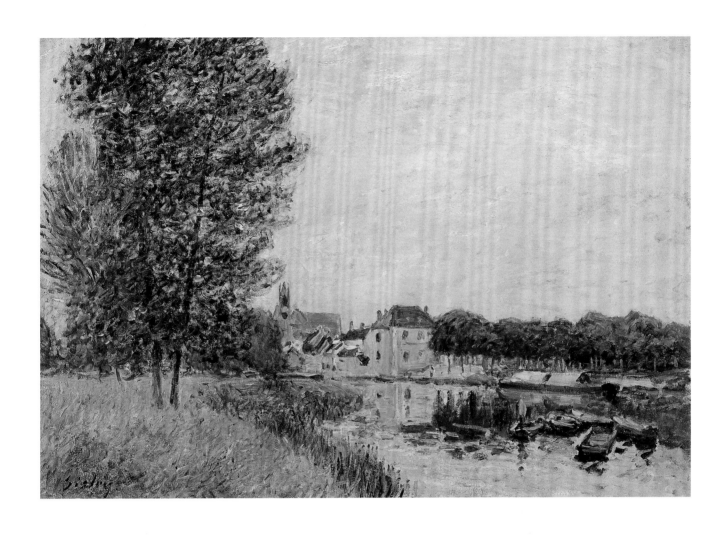

55. ALFRED SISLEY

Moret-sur-le-Loing, 1888

Oil on canvas, 15⅛ × 22⅛

The Joan Whitney Payson Collection at the
Portland Museum of Art, Maine, Promised and
partial gift of John Whitney Payson, 15.1991.9

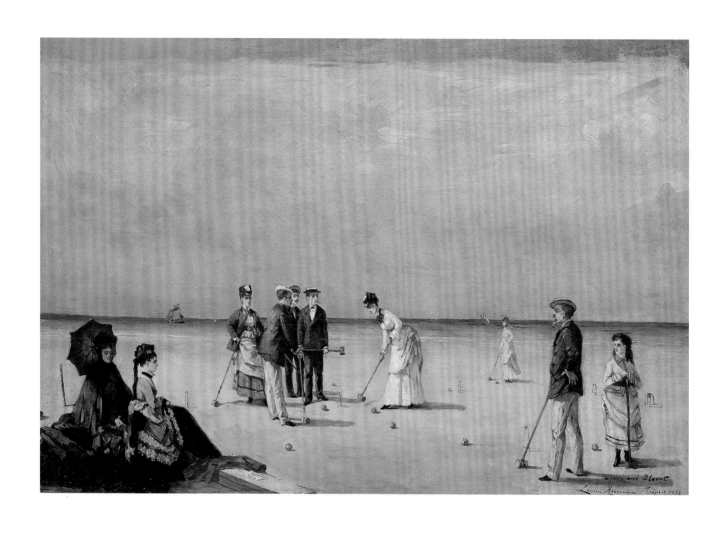

56. LOUISE ABBÉMA

Un Jeu de croquet (*A Game of Croquet*), 1872

Oil on canvas, 15 ¼ × 22

Gail and Tremaine Arkley

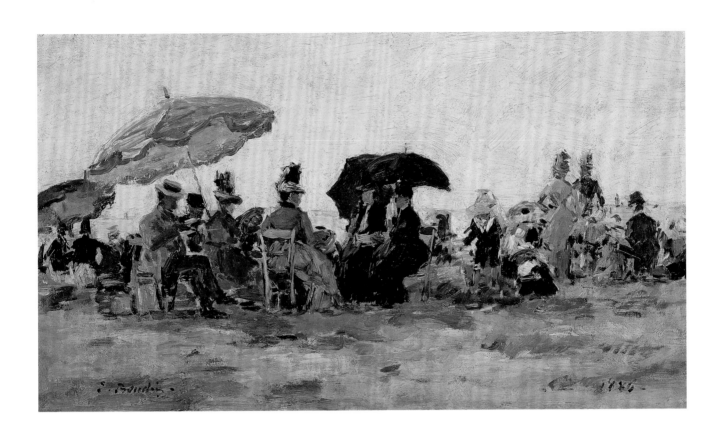

57. EUGÈNE BOUDIN

Scène de plage aux environs de Trouville
(*Beach Scene near Trouville*), 1886

Oil on panel, 7 ³⁄₈ × 13 ¹⁄₈

Scott M. Black Collection

58. GUSTAVE CAILLEBOTTE

Regatta at Trouville, 1884

Oil on canvas, 23 ¾ × 28 ¾

Toledo Museum of Art, Gift of The Wildenstein
Foundation, 1953.69

on the Normandy coast, with a sailing race in the background. In contrast, Abbéma and Boudin focus closer attention on the fashionable tourists' activities on the beach. Abbéma's painting is more highly finished than Boudin's. Yet it still seems aimed at capturing the atmosphere of the open air. Such a scene, populated by men, women, and children, would have been an appropriate place for a woman to experiment with painting out of doors. Despite Baudelaire's definition of the modern artist as male, women such as Abbéma, Berthe Morisot, and Mary Cassatt successfully took up the call for modern art.[30] Significantly, the ability to go out alone into unadulterated nature and to record one's sensations on the spot was not one accorded to women. To begin with, women were not imagined to be in possession of that privileged sensibility that lent drama to the confrontation between the artist and the landscape. Furthermore, social mores dictated that a proper woman did not venture alone onto the streets, let alone wild nature.

Some of the dilemmas faced by women painters are depicted in Alfred Stevens's *Sarah Bernhardt in Her Studio* (circa 1890)(Fig. 59). Bernhardt is shown with palette and brushes in hand, peering out of her studio window onto the street below. Behind her, at approximately the same level as the window, a framed landscape appears to have been recently unveiled. The swath of fabric covering its corner resembles the curtain drawn back at the window where Bernhardt looks down on the street. The artist, enclosed in the room, is shown to be at a distance from the exterior worlds represented by the window and the painting. Although the opportunities for women artists had greatly expanded by the time Stevens painted this portrait of Bernhardt, conventional wisdom about women still hampered their success. Even Sarah Bernhardt, who lived a notoriously unconventional life, was depicted removed from the worlds of both the modern street and unspoiled nature shown in the landscape painting.

Most of the nineteenth-century women who wished to pursue modern art seriously found ways to do so without flouting social conventions too dramatically. When they wished to paint in the open air, for example, Morisot and Cassatt often painted members of their own households in spaces that could be associated with modern life, such as gardens. Abbéma, a longtime intimate of Sarah Bernhardt, pursued such a strategy in *A Game of Croquet* (Fig. 56). The painting shows leisure time in Tréport, a fashionable resort like Deauville or Trouville. Nature is depicted *en plein air*, but in a setting where women out of doors were properly escorted. In this painting, Abbéma answered Baudelaire's call to paint modern life. However, she also chose a subject that would not compromise her own propriety.

Boudin's painting of Trouville is one of many similar scenes he did of the seaside town (Fig. 57). Boudin, a generation older than most of the Impressionists, began exhibiting paintings of the seaside in the official Salon in the 1860s. These large, highly finished paintings produced in his studio

59. ALFRED STEVENS

Sarah Bernhardt in Her Studio, circa 1890

Oil on canvas, 32⅛ × 25¾

Birmingham Museum of Art, Alabama, Gift
from the Estate of Mr. and Mrs. William Hansell
Hulsey, 2000.160

depicted the fashionable Parisian crowds who populated the resort. Thus, like Abbéma's, they answered most directly Baudelaire's exhortation to portray the imagery of contemporary life. Boudin prepared for these Salon paintings as Corot had done, by sketching in the open air. Soon, he and his patrons came to prefer the small-format sketches, and by the 1870s Boudin began to focus on the impressions of Trouville that he would pursue for the rest of his career, such as *Beach Scene near Trouville*. In this small sketch of tourists on the beach, Boudin captures a variety of leisure activities using quick, loose strokes of paint. Under a large umbrella highlighted with red, a man and women with crinolines and hats are arranged in a ragged circle. To their right, two figures dressed in black sit under individual black umbrellas, while behind them children appear to play in the sand. The painting focuses not on the natural beauty of the sea but on the costumes and activities of people taking their leisure. All unfolds with loose, undefined brushstrokes that give the impression of a moment captured in time. The composition is organized horizontally in a panoramic fashion, with the figures placed at the intersection of sky, sea, and sand. Boudin's sketch technique is reminiscent of the Barbizon school, and though he was an early mentor of Monet, who like the older artist also came from Le Havre, his handling of paint became looser later in his career, perhaps due to the advent of Impressionism.

Another image of the Normandy coast, Monet's *The Manneporte Seen from Below* (Fig. 60), contrasts greatly with the works of Boudin and Abbéma. Monet had no interest in representing the metropolitan vacationing crowd. Indeed, he actively sought to avoid them. In January 1883, in the off-season, Monet visited the tourist town of Étretat. While there, he did a series of paintings that focused on landmarks of the coastline. Painting the Manneporte, Monet offered a view of a rock formation familiar to many from tourist guidebooks. However, Monet's image of the Manneporte is colored by his sensibility. We are given a close-range look of the rocky arch as it plunges into the sea. The vantage point suggests the experience of being overwhelmed by the enormous mass. Thick, slightly curved, horizontal strokes of blue and green highlighted with whites show water crashing violently against stone. This painting speaks of the dramas of nature and imagines human beings as powerless to affect them.[31] In his letters, Monet described the impossible task of capturing the ever-changing water and weather as a battle between himself and the elements.[32] In *The Manneporte*, there is no sign of human presence, save the implied one of Monet in the act of painting, and this emphasis on Monet's artistic agency is heightened by the intensity of color.

Monet took a similar approach when he painted *Monte Carlo Seen from Roquebrune* (Fig. 61). He focused on the screening trees in the foreground, the beautiful waters of the bay, and the mountains with their "dog's-head" shape rising behind them.[33] The view thus pictured identifiable features of

60. CLAUDE MONET

La Manneporte vu en aval
(The Manneporte Seen from Below), 1883

Oil on canvas, 28 ¾ × 36 ⁵⁄₁₆

Scott M. Black Collection

61. CLAUDE MONET

Monte Carlo vu de Roquebrune
(*Monte Carlo Seen from Roquebrune*), 1884

Oil on canvas, 25 $\frac{7}{8}$ × 32

Scott M. Black Collection

the landscape, much as *The Manneporte* had done. The town itself, which had become a mecca for wealthy tourists and even housed a well-established casino, appears as a series of incidental, vertical strokes of pale pinkish white that add structure to the landscape but have no particular character. Here, color and brushwork seem to signify Monet's subjective reaction to this manifestation of nature's power. Thus, as in the series of grainstacks that he would paint a few years later, in both *The Manneporte* and *Monte Carlo Seen from Roquebrune*, the motif became a vehicle for the expression of Monet's sensibility signifying an extreme subjectivism. Brushwork and heightened color were more important as signs of Monet's presence at the site than as records of the sensory effects produced by weather and light.

Unlike Monet, who by the 1890s had abandoned the imagery of modern life, Camille Pissarro during that same period embraced modern subject matter anew. For more than a decade Pissarro had been painting highly idiosyncratic imagery of peasants with no overt references to modern life, signifying a more authentic existence, in tune with nature. Pissarro's Neo-Impressionist approach downplayed the links between individual sensibility and the application of paint. The scientific approach to color and Pointillist brushstroke that he embraced for these paintings were associated with the utopian visions of late-nineteenth-century anarchism. In 1891 Pissarro wrote to his son Lucien: "I firmly believe that something of our ideas, born as they are of the anarchist philosophy, passes into our works."[34] Even when he abandoned a Neo-Impressionist use of the Pointillist brushstroke later in the 1890s, Pissarro still retained an interest in peasant subjects and a notion that color harmonies were central to his work. *Gray Morning, with Figures, Éragny* (Fig. 62), painted in 1899, depicts a subject similar to that of his paintings of the 1880s, yet the brushstroke now seems to combine elements of Impressionism with the allover quality of Neo-Impressionism.

If Pissarro's left-leaning politics had led him to create peasant imagery in the 1880s, it seems also to have sent him back to exploring industrial areas. He made trips to Rouen to visit and find "views" much as a tourist might have. Yet the views he chose to depict were not the picturesque images featured in tourist guides but other aspects that fit more with Pissarro's allegiance to the working class. In *View of the Oissel Cotton Mill, near Rouen* (Fig. 63), he showed not only the factories and working boats docked on the near shore but also plumes of smoke rising from many of them. This smoke was an emblem of modernity, referring to the recent industrialization of the city and providing a motif that was evanescent. Pissarro took a similar approach in *The Great Bridge, Rouen* (Fig. 64). This painting shows little of the bright palette seen in the image of Oissel. However, here as in that painting, Pissarro emphasized modernity. Rather than editing out signs of industrialization to give a pleasant view, Pissarro focused on the activity of the working quay and the smoke and steam billowing from chimneys

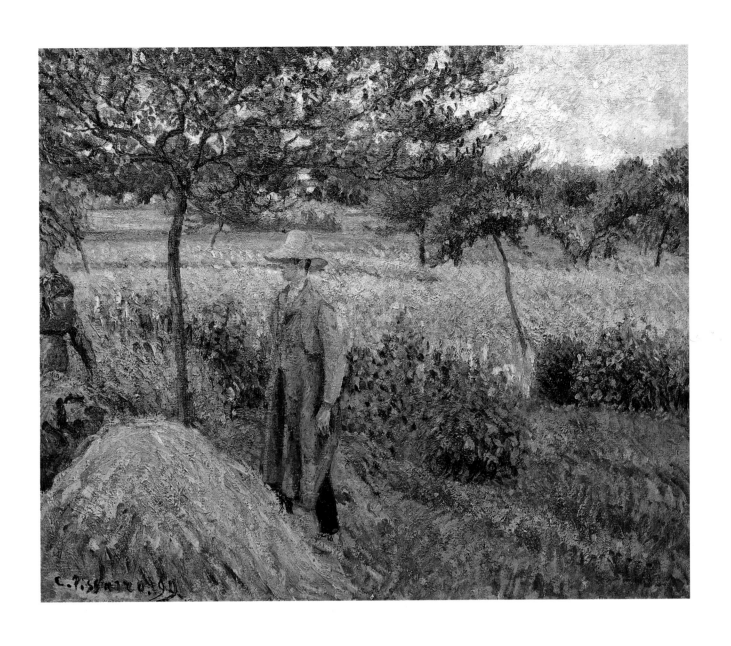

62. CAMILLE PISSARRO

Temps gris, matin avec figures, Éragny
(*Gray Morning, with Figures, Éragny*), 1899

Oil on canvas, 23¾ × 28¹³⁄₁₆

Scott M. Black Collection

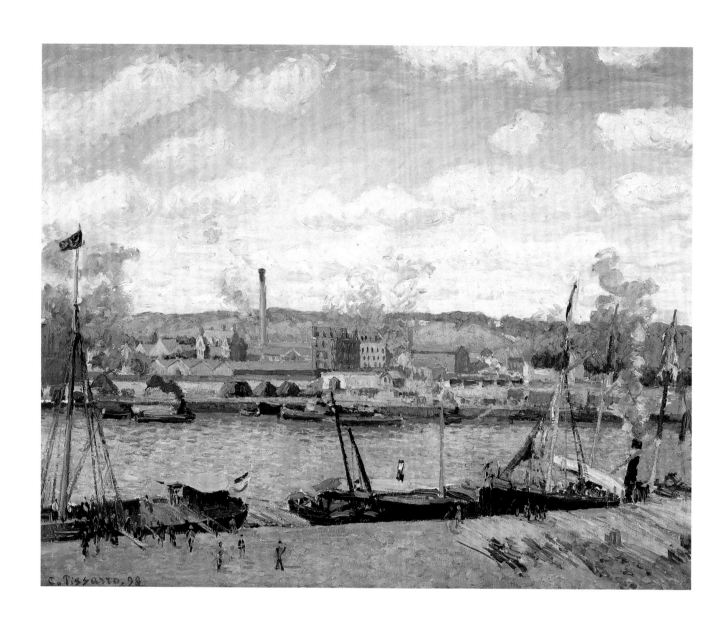

63. CAMILLE PISSARRO

View of the Oissel Cotton Mill, near Rouen, 1898

Oil on canvas, 25 ¾ × 31 ⅞

The Montreal Museum of Fine Arts, Purchase,
John W. Tempest Fund

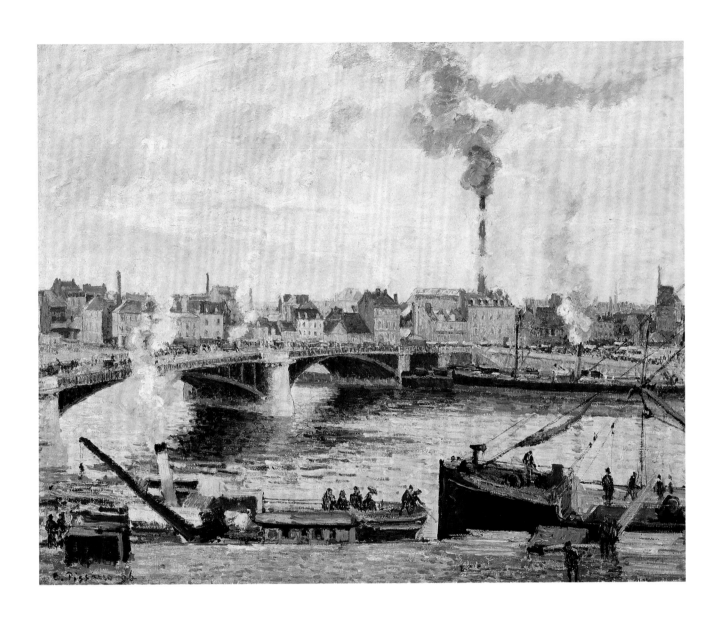

64. CAMILLE PISSARRO

Le Grand Pont, Rouen
(*The Great Bridge, Rouen*), 1896

Oil on canvas, 29 3/16 × 36 1/4

Carnegie Museum of Art, Pittsburgh, Purchase,
00.9

and smokestacks on the near and far banks of the river. He described his attraction to this motif: "What particularly interests me is the motif of the iron bridge in wet weather with all the vehicles, pedestrians, boats, smoke, haze, in the distance; it's so spirited, so alive. I've tried to catch the hive of activity that is Rouen of the embankments."[35] In the 1890s Pissarro also portrayed many images of the city of Paris focusing on great landmarks like the Pont Neuf, the Tuileries Gardens, and the Grands Boulevards. Nothing could be further from Monet's absolute editing out of all signs of modernity in favor of a subjectivized vision of his encounter with the landscape and its atmospheric effects.

POST-IMPRESSIONIST VISIONS AND MODERN LIFE

By the late 1880s a younger generation of artists began to develop alternative approaches to painting that rejected Impressionism's initial commitment to record the fleeting appearances of modern life. Rather than return to the traditional academic approaches that the Impressionists had rejected, these artists looked for new ways to be of their time while avoiding the reliance on the empirical evidence of the senses. This began in the mid-1880s, just around the time when artists such as Monet and Pissarro were also shifting their approaches to painting. All of this work corresponded to a wider cultural shift in which the value of the Positivist mind-set was being questioned. Now the focus was on subjective, psychological states, rather than objective, empirical evidence. The burgeoning sciences of psychology and psychophysiology began to question whether it was advisable for human beings to trust their senses, and experiments with hypnosis and suggestion pointed to the possibility that sensory experience might be influenced as much by emotions and dreams as by empirical sensations.[36] In the cultural realm, this emphasis on the importance of the inner life became manifest in the philosophies of the Germans Friedrich Nietzsche and Arthur Schopenhauer (which experienced a vogue in France in the 1880s) as well as in the increasing visibility and popularity of Symbolism in literature. The last decades of the nineteenth century saw a "shift of emphasis from Naturalism to Symbolism, from a modernity predicated upon urban experience to a modernism endlessly renewed by contact with the primitive and the 'authentic,' and from a manner determined by receptiveness to the specific *impression*, to one driven by a primal need for *expression*."[37] Color, because of its strong links to sensation and sensibility (as opposed to intellect), was seen by virtually all of the young avant-garde painters as the vehicle for new forms of expression divorced from Naturalism. However, they disagreed about the means in which color should be used, as well as the ends that truly modern painting ought to achieve.

Neo-Impressionist artists combined a study of the most current color theories with an interest in the psychophysiology of line and color. Their works, while often evocative of scenes of modern life, no longer claimed to have a

direct relation to an individual motif. Instead, the imagery of modern life was filtered through theories of color and composition with an eye to their potential influence on viewers' senses. The Neo-Impressionists were especially interested in psychophysiological theories that proposed following scientific "laws" that explained the effect certain forms or colors would have on the majority of viewers. Thus, the quest for a more modern approach to painting resulted in a move away from recording the direct impressions of the world as it is experienced and toward submitting those impressions to the laws of color and design derived not from academic tradition but from modern science. Paradoxically, as painting became more "scientific"—as it became based more and more on empirical research by physicists and psychologists into the phenomena of color and expression—it began to look less and less like an empirical record of sensory data experienced by the artist. Not only are the colors adjusted according to abstract scientific principles, but the brushstroke itself has changed. Rather than the varied and nuanced stroke of their Impressionist predecessors, the Neo-Impressionists placed individual dots of color side by side—a method described as "Pointillism." The relative uniformity of these brushstrokes meant that each stroke lost its weight as an individual's reaction to the sensations of the world. Thus, rather than being a reflection of a particular artist with a unique temperament, the Neo-Impressionist brushstroke suggested both objectivity and sharability. Rather than making expressive claims about the subject using loose brushwork and color, as Monet continued to do, the goal became to create an objective experience available to all. For many of the artists experimenting with Neo-Impressionism, this desire for an "objective" modern painting was connected to their commitment to left-wing politics. The rejection of Impressionism's improvised brushstroke was seen as a rejection of individualism and the ways that it supported both artistic exclusivity and a capitalist art market that increasingly used the emphasis on the individual sensibility and genius of the artist to increase sales. Neo-Impressionists like Georges Seurat, Paul Signac, Maximilien Luce, and Théo van Rysselberghe associated the use of scientific color theories with the idea of harmony, and harmony with the anarchists' utopian vision of a more equitable social structure.

Théo van Rysselberghe's *The Regatta* (Fig. 65) is an excellent example of the Neo-Impressionist commitment to harmony. Rysselberghe depicted the classic Impressionist subject of the regatta—a motif that was painted numerous times by Monet in the 1870s and that is represented in this exhibition by Caillebotte's *Regatta at Trouville* (see Fig. 58). However, rather than looking like an impromptu rendering of boats on the water, Rysselberghe carefully planned his composition, color, and brushwork. An abstract harmony of form and color has been imposed on the scene, which cannot be linked to a particular place or time. The sailboats are placed along the horizon in such a way that they invoke musical rhythms. This work has much in common with Signac's images of the

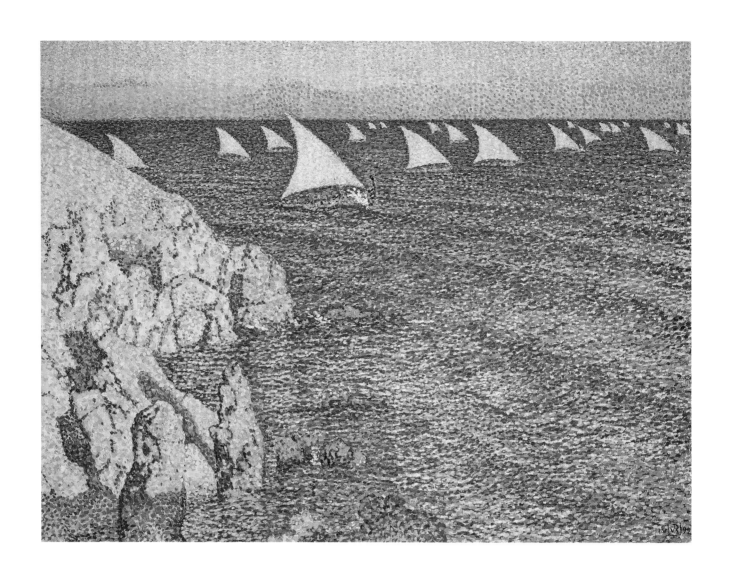

65. THÉO VAN RYSSELBERGHE

La Régate (*The Regatta*), 1892

Oil on canvas with painted wood liner
23 ⅞ × 31 ¾

Scott M. Black Collection

1890s, especially his series of images at Concarneau, all of which were given musical titles (Fig. 66). Rather than defining forms using outline, Rysselberghe gave shape to his composition by contrasting adjacent dots of color. A sense of light and shade is imposed not by varying tone but by shifting the concentration of warm and cool color dots within a particular region of the canvas. Thus, the lighted areas of the rock are made primarily with orange, yellow, and light green dots, while areas of shadow introduce blues into the mix. Reflections of the rocks in the adjacent water are indicated by the integration of orange dots into the predominant blues of the sea. And the sea itself is given waves by the varying number of dark blue, light blue, and violet dots. Even in the largely blue and violet sea, one can find strokes of complementary reds and oranges intermixed. Rather than a reaction to the landscape painted in the open air, this painting superimposes an abstract harmony on a subject associated with modern life. Artists and critics who connected Neo-Impressionism with left-wing politics seemed to believe that the abstract harmony of the works might

66. PAUL SIGNAC

Evening Calm, Concarneau, Opus 220 (Allegro Maestoso), 1891

Oil on canvas, 25½ × 32

The Metropolitan Museum of Art, New York, Robert Lehman Collection, 1975 (1975.1.209)

play some role in inspiring political change. Their work was less an image of modern life than a response to the negative aspects of industrialization and the rise of capitalism in hopes of promoting a more harmonious future.

Maximilien Luce was one of the Neo-Impressionist artists for whom the technique was closely associated with leftist politics. Introduced to the method by Pissarro about 1887, Luce painted in a more or less Neo-Impressionist manner for the rest of his career. Politically active all his life, Luce was among the leftists who congregated at the gatherings of the literary journal *La Revue Moderne*. He contributed illustrations to socialist magazines and produced many sympathetic images of working-class people as well as landscapes and cityscapes.[39] Perhaps on account of his politics, Luce's Neo-Impressionist pictures never become as highly decorative as Rysselberghe's *Regatta*. Even his landscapes usually remain connected to specific places, however abstract the composition may become. In *The Breakwater at Camaret* (Fig. 67), Luce creates an abstract pattern of shapes out of varying dispositions of colored dots while still retaining the characteristic features of the breakwater. In *Éragny, on the Banks of the Epte* (Fig. 68), Luce adheres less strictly to the Pointillist dot of Neo-Impressionism. He uses a variety of repeated small strokes but differentiates their direction according to the objects they portray. In addition, his figures are painted using more traditional modeling, though complementary colors are substituted for tonal modeling. Luce painted many images of industrial workers in urban settings. This painting depicts working-class men and boys at leisure, taking a dip or resting on the riverbank. The work thus recalls one of Luce's first encounters with early Neo-Impressionism when he saw Seurat's *Bathing at Asnières* (1884, The National Gallery, London) at the Salon des Indépendants. However, in contrast to Seurat, Luce sets the workers in a pastoral idyll devoid of any sign of modern industrialism. In this painting, Luce seems to be imagining harmonious possibilities rather than invoking the dire circumstances of the working class.

An account of Luce's work in the left-wing publication *Le Combat* written in 1890 described him as "one of those who will contribute to ending the misunderstanding between artists and the people. He is one of those who will help us reach complete harmony."[40] In 1894 Luce was one of many cultural figures jailed and tried (and ultimately acquitted) in the infamous Procès des Trente (Trial of the Thirty). The trial was an attempt by the French state to reassert itself in response to the assassination attempt on president Sadi Carnot by an Italian anarchist.[41]

In contrast to the Neo-Impressionists, for whom a modern use of color was guided by scientific and political principles, the artists associated with Symbolism—Paul Gauguin, Émile Bernard, Maurice Denis, and others—attempted to find in painting a parallel to Symbolism in literature. Proponents of Symbolist aesthetics rejected the notion that the purpose of the arts was to

67. MAXIMILIEN LUCE

Camaret, la Digue (*The Breakwater at Camaret*), 1895

Oil on canvas, 25 ⅝ × 36 ¼

Scott M. Black Collection

68. MAXIMILIEN LUCE

Éragny, les bords de l'Epte
(*Éragny, on the Banks of the Epte*), 1899

Oil on canvas, 32 × 45¾

Scott M. Black Collection

represent the world as it appears to our senses. They proposed to create works that would use suggestive (and often abstract) forms, images, or sounds to embody transcendent (and sometimes spiritual) ideas and thus offer their readers, viewers, or listeners an experience of a Truth, Beauty, or the Idea, beyond the material realm. Symbolism—be it in literature, music, or the visual arts—was thus characterized by a paradox: it relies on an emphasis of material form (decorative patterns in painting, repeated sounds in poetry or music, or words arranged on the page in the literary arts) as the vehicle for transcending the material or empirical world. This foregrounding of form links Symbolism to the emergence of modernist abstraction in art and literature, which emphasized the viewer's or reader's sensation of the work, rather than the artist or writer's sensation of nature.[42]

One of the key texts informing Symbolism was Baudelaire's poem "Correspondances" (1857). In it, he suggests that we inhabit a world where nature can serve as a "forest of symbols" to which the poet is especially attuned. Everyday objects and experiences offer secret correspondences between sounds, scents, and colors in which the poet deciphers a higher meaning. Baudelaire's poem evokes two ideas that are central to Symbolism: first, the emphasis on the role of the artist or poet as a gifted seer capable of identifying connections that point beyond the perceptible world, and, second, the importance of formal echoes in sensory data where scents, colors, and sounds "se répondent" (respond to one another) in synesthesia, the connection between different sensory realms. Another important model for Symbolist artists was the poet Stéphane Mallarmé, who stressed the importance of suggestion:

> To name an object is to suppress three quarters of the pleasure of the poem which is meant to be deciphered little by little: suggestion, that is the dream. This is the perfect use of mystery which constitutes the symbol: to evoke an object little by little in order to show a state of the soul or, conversely, to choose an object and glean from it an emotional state by a series of decipherments.[43]

Émile Bernard's *Iron Bridges at Asnières* (Fig. 69) participates in the Symbolist aesthetic of suggestion. Bernard chose a subject, the railroad bridge, that was already associated with Impressionism. (It had been portrayed numerous times by Monet in the 1870s.) He depicted a locale, Asnières, that Seurat had famously portrayed in his *Bathers at Asnières* as a site of modern, working-class leisure. Indeed, Bernard seems to have chosen the subject carefully to stake a claim to a kind of painting that actively opposed both the empirical basis of Impressionism and the scientific and social agenda of Neo-Impressionism. Bernard's painting is characterized by large areas of color arranged in an interlocking pattern defined by dark outlines. The diagonal of the shore, the shape

69. ÉMILE BERNARD

Iron Bridges at Asnières, 1887

Oil on canvas, 18⅛ × 21⅜

The Museum of Modern Art, New York,
Grace Rainey Rogers Fund, 113.1962

of an overturned boat, the bridge with its train, and the figures—all of these are simplified into abstract forms that only vaguely recall their real-life counter-parts. These silhouettes of forms, where no detail is given, impart a decorative quality to the work. Furthermore, the viewer's eye is drawn to the figures, who are placed at the intersection of the diagonal riverbank and horizontal bridge. They are more like shadows than forms and lend a sense of mystery to the work, in keeping with Mallarmé's principles.

In the late 1880s Gauguin left Paris and began to work in the town of Pont-Aven in Brittany, where he was joined by Bernard and others. In moving to Brittany, the artists sought to escape from modern urban life for a more "authentic" existence surrounded by a peasant culture they believed to be primitive. These artists wanted to think that the Breton peasants, especially the women, remained unaffected by the onslaught of modernity and thus were closer to an originary state of being in which the senses were not yet dulled by daily exposure to decadent European culture. Symbolist artists who embraced the primitive wished to return their own consciousnesses to equivalent states of innocence and instinctiveness. Thus primitivism played an important role in the Symbolist movement. Artists like Gauguin, Bernard, and Georges Lacombe embraced both "primitive" subject matter and simplified, more elemental form.

Bernard's *Madeleine in the Woods of Love* from 1892 (Fig. 70) is related to this Breton context. Bernard had first treated the subject in 1888 while working with Gauguin in Pont-Aven. The Bois d'Amour was a forest in Brittany where Gauguin is said to have given Paul Sérusier the lesson in painting that would lead to the formation of the Nabis group: "How do you see this tree, Gauguin asked in front of a corner of the Bois d'Amour: is it green? Then paint it green, the most beautiful green on your palette; and that shadow, rather blue? Don't be afraid to paint it as blue as possible."[44] This heightening of color to the point of abstraction is clearly visible in Bernard's painting.

The name of the forest, with its reference to "love," surely also suggested symbolic significance. Bernard depicted his younger sister Madeleine from the shoulders up in three-quarters view, wreathed in flowers, which approximate the laurels seen in Greek portrait busts. The landscape behind her has a wholly decorative feeling. It is divided into large areas structured around intersections of vertical and horizontal curves. These are filled in with mostly vertical strokes of complementary colors that have only a distant relation to the colors one would see in nature. The tree at the left, rising from the bottom to the top of the image, is painted in violet-blue highlighted with yellow. The background is dominated by blues and oranges. Bernard has signed his name in red on the green grass in the lower right. The female figure on the right is rendered in a reddish orange highlighted with a deep blue. Thus, the artist took the same rules of color used by the Impressionists and Neo-Impressionists and used

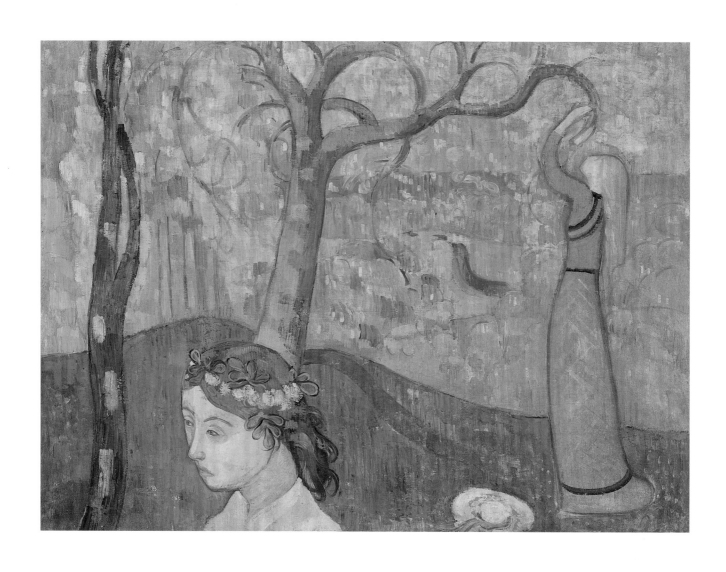

70. ÉMILE BERNARD

Madeleine au Bois d'Amour
(*Madeleine in the Woods of Love*), 1892

Oil on canvas, 29⅛ × 39⁷⁄₁₆

Scott M. Black Collection

them as a basic theme on which he imposed many variations. However, in Bernard's painting, the color contrasts were not meant to evoke the feeling of light in the open air. Neither were they used to achieve effects of modeling. Rather, they enhanced the decorative rhythms of the scene and increased its suggestive potential.

The landscape appears not only as a decorative harmony but also as a dreamlike expression of Bernard's idea of Madeleine. The tree that cuts across the center foreground connects the female figure at the right to the bust of Madeleine. Its branches extend out to this figure's arms. The arms continue the decorative curve of the tree's branches. The shadow of darker green that runs from the base of the tree leads to the bottom of the female figure's dress. The composition is thus centered on the connection between the female figure and Madeleine, and the background reads as a dream image emanating from Madeleine.

This figure, shown in silhouette, with no identifying details, is full of suggestive potential. But what is she saying about Madeleine and her dream life? In addition to being physically connected to the tree, she is composed of similar colors. In a sense, then, she is an extension of, or corollary to, nature. The implication that she is picking something from the branch of the tree also suggests connections to the Garden of Eden. Bernard is bringing out the symbolic potential of both the forest and the girl, nature as a "forest of symbols." The hat on the ground near the figure on the right is decorated with flowers and ribbons that link it to the specificity of contemporary life, but it has been cast aside in favor of the imagery of nature and origins. Madeleine thus becomes emblematic of the more authentic, uncorrupted possibilities celebrated by the Symbolists, and the decorative, highly colored landscape surrounding her is less a setting for her actions than an extension of her thoughts, feelings, or potentials.

In France the Symbolist interest in the primitive was also connected to a vogue for things Japanese that emerged when the market between Japan and the West was opened in 1854. In particular, Japanese prints had become abundant and were collected by artists and connoisseurs. Vincent van Gogh, Gauguin, and many other late-nineteenth-century artists looked to the bold patterns and non-Western perspective of Japanese prints as a seemingly primitive source of artistic ideas. In *Madeleine in the Woods of Love*, Bernard follows van Gogh and Gauguin in using a motif derived from Japanese prints in which trunk and branches of a tree extend across the foreground to the top edge of the picture. Lacombe's *The Gray Sea* (Fig. 71) also shows the combined influences of the Nabis aesthetic and Japanese prints. Lacombe spent his summers on the coast of Brittany, where he came into contact with the Nabi artists. Lacombe used complementary colors to create a stylized decorative pattern, in which the forms of the waves were strongly influenced by the prints of Hiroshige.

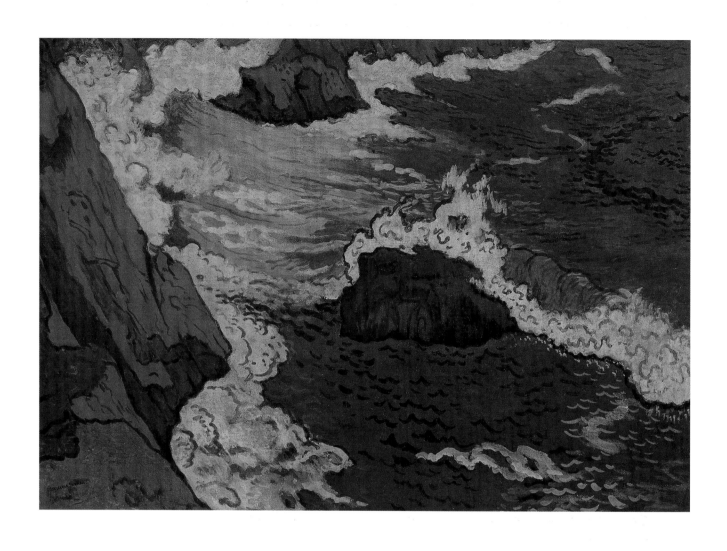

71. GEORGES LACOMBE

La Mer grise (*The Gray Sea*), 1895–96

Oil on canvas, 18⅛ × 25⅝

Utah Museum of Fine Arts, University of Utah,
Salt Lake City, Purchased with funds from
Friends of the Art Museum, 1974.045

Bernard and Lacombe created paintings that look forward to the abstraction of the early twentieth century. Despite the fact that their work rejected the imagery of modern life, their desire to look back toward the "primitive" only makes sense in relation to depictions of modern life. For the active rejection of the empirical signs of modernity could only have been imagined by these artists in a context in which modern life had begun to be perceived as threatening to artistic creativity. In addition, the form their retreat from modernity took—the large patches of suggestive color—could only have been imagined once Impressionism had freed painting from the underpinning of academic aesthetics and promulgated a reliance on color as the structuring principle of painting.

Notes

1. Marshall Berman, *All That Is Solid Melts into Air: The Experience of Modernity* (New York: Penguin Books, 1982).

2. Karl Marx and Friedrich Engels, *The Communist Manifesto* (New York: Penguin Books, 2002), p. 223.

3. Charles Baudelaire, "The Painter of Modern Life," in *Art in Theory, 1815–1900: An Anthology of Changing Ideas*, ed. Charles Harrison and Paul Wood with Jason Gaiger (Oxford: Blackwell Publishers, 1998), p. 497.

4. Baudelaire, 1998, pp. 495–96.

5. Jules-Antoine Castagnary, "The Exhibition of the Boulevard des Capucines—Les Impressionistes," *Le Siècle*, Paris, April 29, 1874, in Harrison and Wood, 1998, p. 573.

6. Louis Émile Edmond Duranty, "The New Painting: Concerning the Group of Artists Exhibiting at the Durand-Ruel Galleries," in *The New Painting: Impressionism, 1874–1886*, exh. cat. (San Francisco: The Fine Arts Museums of San Francisco, 1986), p. 39.

7. Duranty, 1986, p. 40.

8. For a discussion of the subjectivity of Impressionism, see Richard Shiff, *Cézanne and the End of Impressionism* (Chicago: University of Chicago Press, 1984).

9. Other kinds of sketches included *esquisse* or *pochade*—"rapid notation of a whole composition," *étude*—"a closer study of a part of it," *ébauche*—"the lay-in, the first stages of work on a particular canvas." All of these contrast to tableau, which designates a fully finished canvas. For an excellent discussion of these terms and their use by particular artists, see John House, *Impressionism: Paint and Politics* (New Haven: Yale University Press, 2004), pp. 45–69.

10. Leroy, in Harrison and Wood, 1998, p. 576.

11. Corot, in Harrison and Wood, 1998, p. 535.

12. Nicholas Green, "Dealing in Temperaments: Economic Transformation of the Artistic Field in France during the Second Half of the Nineteenth Century," *Art History* 10, no. 1 (March 1987): 59–78.

13. Paul Adam, "Peintres Impressionistes," *La Révue Contemporaine*, Paris, May 1886, trans. Akane Kawakami, in Harrison and Wood, 1998, p. 959.

14. Blanc, in Harrison and Wood, 1998, pp. 620–21.

15. Blanc, in Harrison and Wood, 1998, p. 623.

16. Blanc, in Harrison and Wood, 1998, p. 623.

17. Blanc, in Harrison and Wood, 1998, p. 619.

18. Blanc, in Harrison and Wood, 1998, p. 619.

19. Blanc, in Harrison and Wood, 1998, p. 625.

20. Victor Hugo, quoted in Wolfgang Schivelbusch, *The Railway Journey: The Industrialization of Time and Space in the Nineteenth Century* (Berkeley and Los Angeles: University of California Press, 1986), p. 55.

21. *A Day in the Country: Impressionism and the French Landscape*, exh. cat. (Los Angeles: Los Angeles County Museum of Art, 1984), p. 146.

22. See Paul Hayes Tucker, *Monet at Argenteuil* (New Haven: Yale University Press, 1982).

23. *Armand Guillaumin, 1841–1927, un maître de l'impressionisme français*, exh. cat. (Lausanne: Bibliothèque des Arts, 1996), p. 28.

24. *Impressionism and Post-Impressionism*, exh. cat. (Chicago: The Art Institute of Chicago, 2000), pp. 44, 63–64.

25. Lausanne, 1996, p. 14.

26. Claudia Einecke, *Armand Guillaumin*, exh. cat. (New York: Berry-Hill Galleries, 2004), p. 7.

27. Schivelbusch, 1986, pp. 53–56.

28. Quoted in Luce Abélès, "Mallarmé, Whistler and Monet," in Katharine Lochnan, *Turner, Whistler, Monet: Impressionist Visions*, exh. cat. (Toronto: Art Gallery of Ontario, 2004), p. 167. Original text in letter to Claude Monet, July 21, 1890.

29. Los Angeles, 1984, p. 43.

30. Significantly, critics described the work of women artists in very different terms than the paintings of their male counterparts, often seeing it as a direct expression of their femininity. See Tamar Garb, "'L'Art Feminin': The Formation of a Critical Category in Late Nineteenth-Century France," *Art History* 12 (1989): 39–65.

31. See Robert L. Herbert, *Monet on the Normandy Coast, 1867–1886* (New Haven: Yale University Press, 1994), p. 86.

32. See Steven Z. Levine, *Monet, Narcissus and Self-Reflection: The Modernist Myth of the Self* (Chicago: University of Chicago Press, 1995), pp. 30–35.

33. See Joachim Pissarro, *Monet and the Mediterranean*, exh. cat. (New York: Rizzoli, 1997).

34. Camille Pissarro, April 13, 1891, in Harrison and Wood, 1998, p. 1030.

35. Los Angeles, 1984, p. 136.

36. See Debora Silverman, "Psychologie Nouvelle," in *Nineteenth Century Visual Culture Reader*, ed. Vanessa R. Schwartz and Jeannene Przyblyski (London: Routledge, 2004), pp. 371–92.

37. Harrison and Wood, 1998, p. 876.

38. Martha Ward, *Pissarro, Neoimpressionism, and the Spaces of the Avant-Garde* (Chicago: University of Chicago Press, 1996), p. 148.

39. Carrie Haslett, "Neo-Impressionism: Artists on the Edge," in *Neo-Impressionism: Artists on the Edge*, exh. cat. (Portland, Me.: Portland Museum of Art, 2002), p. 25.

40. Robert Bernier, April 1, 1890, quoted in Ward, 1996, p. 151.

41. Haslett, 2002, p. 25.

42. Jennifer L. Shaw, "Symbolism in Literature, the Visual Arts, and Music," in *New Dictionary of the History of Ideas*, ed. Maryanne Cline Horowitz (New York: Charles Scribner Sons, 2005).

43. Jules Huret, *Enquete sur l'évolution littéraire* (Paris: Fasquelle, 1913), pp. 55–65.

44. Maurice Denis, "L'Influence de Paul Gauguin," in *Du symbolisme au classicisme: Théories* (Paris, 1964).

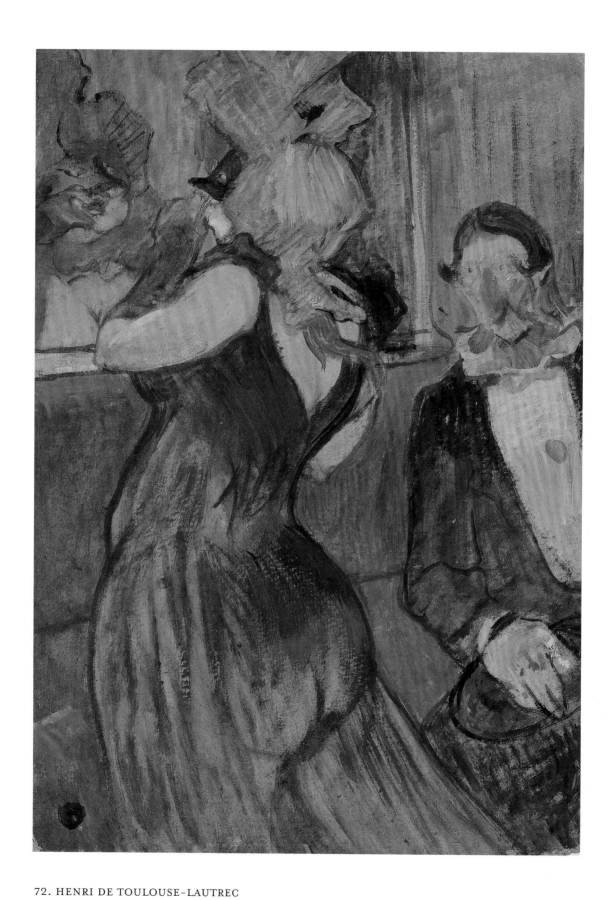

72. HENRI DE TOULOUSE-LAUTREC

Repos pendant le bal masqué
(*Respite from the Masked Ball*), circa 1899

Oil and gouache on cardboard, 22½ × 15¹³⁄₁₆

Denver Art Museum, Gift of T. Edward
and Tullah Hanley Collection, 1974.359

Exhibition Checklist

Works are listed alphabetically by artist. Dimensions are in inches, height preceding width.

LOUISE ABBÉMA
France, 1858–1927
Un Jeu de croquet (A Game of Croquet), 1872
Oil on canvas, 15¼ × 22
Gail and Tremaine Arkley

JEAN BÉRAUD
France, 1849–1936
Les Halles, 1879
Oil on canvas, 25⅝ × 32
The Haggin Museum, Stockton, California, 1931.391.4

JEAN BÉRAUD
France, 1849–1936
Sur le boulevard (On the Boulevard), circa 1888
Oil on canvas, 21 × 14¾
The Haggin Museum, Stockton, California, 1931.391.3

JEAN BÉRAUD
France, 1849–1936
Le Café, 1908
Oil on canvas, 17⅜ × 24⅜
Herbert Black

ÉMILE BERNARD

France, 1868–1941

Iron Bridges at Asnières, 1887

Oil on canvas, 18⅛ × 21⅜

The Museum of Modern Art, New York, Grace Rainey Rogers Fund, 113.1962

ÉMILE BERNARD

France, 1868–1941

Madeleine au Bois d'Amour (*Madeleine in the Woods of Love*), 1892

Oil on canvas, 29 ⅛ × 39 ⁷/₁₆

Scott M. Black Collection

MAURICE BIAIS

Germany, circa 1875–1926

La Maison moderne, circa 1900

Lithograph on paper, 44 ¾ × 30

The Museum of Modern Art, New York,
Gift of Leonard and Evelyn Lauder, 1987

PIERRE BONNARD

France, 1867–1947

Le Canotage (*Rowing*), from *L'Histoire naturelle*, for *L'Album d'estampes originales de la Galerie Vollard*, 1897

Lithograph printed in four colors on China paper, image: 10 ⁵/₁₆ × 18⅝,
sheet: 16 × 21⅜

Smith College Museum of Art, Northampton, Massachusetts, Gift of Selma
Erving, class of 1927, SC 1978: 1-2

PIERRE BONNARD

France, 1867–1947

Avenue du Bois, from *Quelques Aspects de la vie de Paris* (*Some Scenes of Parisian Life*), 1899

Transfer lithograph in five colors on white wove paper, image: 12 ⅜ × 18,
sheet: 16 ⅛ × 20 ¹³/₁₆

Smith College Museum of Art, Northampton, Massachusetts, Gift of Selma
Erving, class of 1927, SC 1978: 1-5

PIERRE BONNARD

France, 1867–1947

Au théâtre (*At the Theater*), from *Quelques Aspects de la vie de Paris* (*Some Scenes of Parisian Life*), 1899

Transfer lithograph in four colors on paper, image: 8 × 15 ¾, sheet: 16 × 21 ⅛

Smith College Museum of Art, Northampton, Massachusetts, Gift of Selma
Erving, class of 1927, SC 1978: 1-13

PIERRE BONNARD

France, 1867–1947

Boulevard, from *Quelques Aspects de la vie de Paris* (*Some Scenes of Parisian Life*), 1899

Transfer lithograph in four colors on paper, image: 6 ⅞ × 17 ⅛, sheet: 14 ⅛ × 20 ⅞

Smith College Museum of Art, Northampton, Massachusetts, Gift of Selma Erving, class of 1927, SC 1978: 1-9

PIERRE BONNARD

France, 1867–1947

Coin de rue vue d'en haut (*Street Corner Seen from Above*), from *Quelques Aspects de la vie de Paris* (*Some Scenes of Parisian Life*), 1899

Transfer lithograph in four colors on white wove paper, image: 14⅝ × 8⅜, sheet: 21 × 16⅛

Smith College Museum of Art, Northampton, Massachusetts, Gift of Selma Erving, class of 1927, SC 1978: 1-16

PIERRE BONNARD

France, 1867–1947

Rue, le soir, sous la pluie (*Street, Evening, in the Rain*), from *Quelques Aspects de la vie de Paris* (*Some Scenes of Parisian Life*), 1899

Transfer lithograph in four colors on white wove paper, image: 10⅛ × 14, sheet: 16 × 21

Smith College Museum of Art, Northampton, Massachusetts, Gift of Selma Erving, class of 1927, SC 1978: 1-14

EUGÈNE BOUDIN

France, 1824–1898

Scène de plage aux environs de Trouville (*Beach Scene near Trouville*), 1886

Oil on panel, 7⅜ × 13⅛

Scott M. Black Collection

GUSTAVE CAILLEBOTTE

France, 1848–1894

Regatta at Trouville, 1884

Oil on canvas, 23¾ × 28¾

Toledo Museum of Art, Gift of The Wildenstein Foundation, 1953.69

MARY CASSATT

United States, 1844–1926

Simone in a Plumed Hat, circa 1903

Pastel over counterproof, 24⅛ × 19⅝

Scott M. Black Collection

PAUL CÉZANNE

France, 1839–1906

Arbres au Jas de Bouffan (*Trees in the Jas de Bouffan*), circa 1875–76

Oil on canvas, 21⅜ × 28⅞

Scott M. Black Collection

EDGAR CHAHINE

active France, 1874–1947

La Danseuse de corde (*Tightrope Walker*), 1906

Etching on paper, 21³/₁₆ × 15

Jane Voorhees Zimmerli Art Museum, Rutgers, The State University of New Jersey: David S. and Mildred H. Morse Art Acquisition Fund, 82.029.001

EDGAR CHAHINE

active France, 1874–1947

Wrestlers, 1904

Etching on paper, 22¼ × 14¹/₁₆

Jane Voorhees Zimmerli Art Museum, Rutgers, The State University of New Jersey, David A. and Mildred H. Morse Art Acquisition Fund, 82.68.15

EDGAR DEGAS

France, 1834–1917

Children and Ponies in a Park, circa 1867

Oil on canvas, 39¾ × 35³/₁₆

From the Joan Whitney Payson Collection

EDGAR DEGAS

France, 1834–1917

Mary Cassatt at the Louvre: The Etruscan Gallery, 1879–80

Softground etching, etching, aquatint, and drypoint printed in black on thin Japan paper, plate: 10⅝ × 9⁵/₁₆, sheet: 14 × 10⅝

Smith College Museum of Art, Northampton, Massachusetts,
Gift of Selma Erving, class of 1927, SC 1972: 50-17

EDGAR DEGAS

France, 1834–1917

La Blanchisseuse repassant (*The Laundress Ironing*), circa 1882–86

Oil on canvas, 25½ × 26¼

Courtesy of the Reading Public Museum, Reading, Pennsylvania

EDGAR DEGAS
France, 1834–1917
Pagans et le père Degas (*Pagans and Degas's Father*), 1888–94
Oil on canvas, 32 × 33
Scott M. Black Collection

EDGAR DEGAS
France, 1834–1917
Danseuse assise (*Seated Dancer*), 1894
Pastel on joined paper, mounted on board, 22¾ × 17¾
Scott M. Black Collection

EDGAR DEGAS
France, 1834–1917
Danseuse à l'éventail (*Dancer with Fan*), undated
Charcoal and pastel on thin buff paper, laid down on heavy paper, 19⅛ × 15
Private collection

MAURICE DENIS
France, 1870–1943
Les Premiers Pas de Noële (*Noële's First Steps*), 1897
Oil on paperboard, 18¾ × 24½
Scott M. Black Collection

LOUIS DUMOULIN
France, 1860–1924
Carp Banners in Kyoto, 1888
Oil on canvas, 18⅛ × 21⅜
Museum of Fine Arts, Boston, Fanny P. Mason Fund in memory of Alice
Thevin, 1986.582

JEAN-LOUIS FORAIN
France, 1852–1931
Behind the Scenes, circa 1880
Oil on canvas, 18¼ × 15⅛
National Gallery of Art, Washington, Rosenwald Collection, 1943.11.4

VINCENT VAN GOGH

Netherlands, 1853–1890

Jeune Fille au ruban rouge (*Young Woman with Red Bow*), second half December 1885

Oil on canvas, 23⅝ × 19¾

Private collection

EUGÈNE-SAMUEL GRASSET

France, 1841–1917

Morphine Addict, 1897

Lithograph on paper, 29½ × 23⁷⁄₁₆

Jane Voorhees Zimmerli Art Museum, Rutgers, The State University of New Jersey, Friends Purchase Fund, 77.054.001

JEAN-BAPTISTE-ARMAND GUILLAUMIN

France, 1841–1927

La Plaine de Bagneux, au sud de Paris (*The Plain of Bagneux, South of Paris*), 1874

Oil on canvas, 25¼ × 30

Private collection. Courtesy of Wildenstein & Co., Inc., New York

JEAN-BAPTISTE-ARMAND GUILLAUMIN

France, 1841–1927

The Arcueil Aqueduct at Sceaux Railroad Crossing, circa 1874

Oil on canvas, 20¼ × 25⅝

The Art Institute of Chicago, Restricted gift of Mrs. Clive Runnells, 1970.95

WINSLOW HOMER

United States, 1836–1910

A Parisian Ball—Dancing at the Casino, 1867

Harper's Weekly 11 (November 23, 1867): 745

Wood engraving on wove paper, 16⅜ × 11¾

Portland Museum of Art, Maine, Gift of Peggy and Harold Osher, 1991.70.27

WINSLOW HOMER

United States, 1836–1910

A Parisian Ball—Dancing at the Mabille, Paris, 1867

Harper's Weekly 11 (November 23, 1867): 744

Wood engraving on wove paper, 16⅜ × 11¾

Portland Museum of Art, Maine, Gift of Peggy and Harold Osher, 1991.70.87

WINSLOW HOMER

United States, 1836–1910

Art Students and Copyists in the Louvre Gallery, Paris, 1868

Harper's Weekly 12 (January 11, 1868): 25

Wood engraving on wove paper, 16⅜ × 11⅞

Portland Museum of Art, Maine, Gift of Peggy and Harold Osher, 1991.25.11

HENRI-GABRIEL IBELS

France, 1867–1936

At the Circus, 1893

Lithograph on paper, 19½ × 10¼

Jane Voorhees Zimmerli Art Museum, Rutgers, The State University of New Jersey: David S. and Mildred H. Morse Art Acquisition Fund, 80.012.001

GEORGES LACOMBE

France, 1868–1916

La Mer grise (The Gray Sea), 1895–96

Oil on canvas, 18⅛ × 25⅝

Utah Museum of Fine Arts, University of Utah, Salt Lake City, Purchased with funds from Friends of the Art Museum, 1974.045

MAXIME LALANNE

France, 1827–1886

Rear View of Tenements, 1864

Etching on off-white laid paper, plate: 9⅜ × 12⅝, sheet: 13½ × 17⅜

Smith College Museum of Art, Northampton, Massachusetts, gift of A. V. Galbraith in memory of Helen McIntosh Galbraith, class of 1901, SC 1959: 122

LOUIS-AUGUSTE-MATHIEU LEGRAND

France, 1863–1951

Au bar, 1908

Etching and drypoint on paper, 17½ × 12¼

Jane Voorhees Zimmerli Art Museum, Rutgers, The State University of New Jersey, Gift of Reese and Marilyn Arnold Palley, 1991.0441.002

LOUIS-AUGUSTE-MATHIEU LEGRAND

France, 1863–1951

Le Passant, undated

Drypoint on paper, image: 5¾ × 8⅜

Fine Arts Museums of San Francisco, Achenbach Foundation for Graphic Arts, 1963.30.30760

MAXIMILIEN LUCE

France, 1858–1941

Camaret, la Digue (The Breakwater at Camaret), 1895

Oil on canvas, 25⅝ × 36¼

Scott M. Black Collection

MAXIMILIEN LUCE

France, 1858–1941

Éragny, les bords de l'Epte (Éragny, on the Banks of the Epte), 1899

Oil on canvas, 32 × 45¾

Scott M. Black Collection

ÉDOUARD MANET

France, 1832–1883

Children in the Tuileries Gardens, circa 1861–62

Oil on canvas, 15 × 18¼

Museum of Art, Rhode Island School of Design, Providence, Museum Appropriation, 42.190

HENRI MATISSE

France, 1869–1954

Le Pont St. Michel, circa 1901

Oil on canvas, 18¼ × 22

Scott M. Black Collection

CHARLES MAURIN

France, 1856–1914

Bal des Quatr'z Arts, 1894

Pastel on paper, 29⅜ × 24

Jane Voorhees Zimmerli Art Museum, Rutgers, The State University of New Jersey, Gift of Carleton A. Holstrom, 1986.0884

CHARLES MAURIN

France, 1856–1914

Café-Concert, 1893

Etching on paper, 5⅜ × 8½

Jane Voorhees Zimmerli Art Museum, Rutgers, The State University of New Jersey: Friends Purchase Fund, 76.031.004

CLAUDE MONET

France, 1840–1926

The Seine at Bougival, 1869

Oil on canvas, 25¾ × 36⅜

Currier Museum of Art, Museum Purchase, Currier Funds, 1949.1

CLAUDE MONET

France, 1840–1926

La Seine à Lavacourt (*The Seine at Lavacourt*), 1878

Oil on canvas, 22⅛ × 28⅞

Scott M. Black Collection

CLAUDE MONET

France, 1840–1926

La Seine à Vétheuil (*The Seine at Vétheuil*), circa 1880

Oil on canvas, 23 × 28¾

Portland Museum of Art, Maine, Gift of Mrs. Stuart Symington, 1998.95

CLAUDE MONET

France, 1840–1926

La Manneporte vu en aval (*The Manneporte Seen from Below*), 1883

Oil on canvas, 28¾ × 36 ⁵/₁₆

Scott M. Black Collection

CLAUDE MONET

France, 1840–1926

Monte Carlo vu de Roquebrune (*Monte Carlo Seen from Roquebrune*), 1884

Oil on canvas, 25⅞ × 32

Scott M. Black Collection

CLAUDE MONET

France, 1840–1926

Le Train à Jeufosse (*The Train at Jeufosse*), 1884

Oil on canvas, 33⅜ × 39½

Private collection

CAMILLE PISSARRO

France, 1830–1903

Le Grand Pont, Rouen (*The Great Bridge, Rouen*), 1896

Oil on canvas, 29³/₁₆ × 36¼

Carnegie Museum of Art, Pittsburgh, Purchase, 00.9

CAMILLE PISSARRO

France, 1830–1903

The Boulevard Montmartre on a Winter Morning, 1897

Oil on canvas, 25½ × 32

The Metropolitan Museum of Art, Gift of Katrin S. Vietor, in loving memory of Ernest G. Vietor, 1960, 60.174

CAMILLE PISSARRO

France, 1830–1903

View of the Oissel Cotton Mill, near Rouen, 1898

Oil on canvas, 25¾ × 31⅞

The Montreal Museum of Fine Arts, Purchase, John W. Tempest Fund

CAMILLE PISSARRO

France, 1830–1903

Temps gris, matin avec figures, Éragny (*Gray Morning, with Figures, Éragny*), 1899

Oil on canvas, 23¾ × 28 ¹³/₁₆

Scott M. Black Collection

CAMILLE PISSARRO

France, 1830–1903

Le Louvre, soleil d'hiver, matin (*The Louvre, Winter Sun, Morning*), 1901

Oil on canvas, 29⅛ × 36¼

Scott M. Black Collection

CAMILLE PISSARRO

France, 1830–1903

Pont Neuf, Paris, 1901

Oil on canvas, 17¾ × 14¾

Allen Memorial Art Museum, Oberlin College, Ohio, R. T. Miller, Jr. Fund, 1941

PIERRE-AUGUSTE RENOIR

France, 1841–1919

Confidences, circa 1873

Oil on canvas, 32 × 23¾

The Joan Whitney Payson Collection at the Portland Museum of Art, Maine, Gift of John Whitney Payson, 1991.62

HENRI RIVIÈRE

France, 1864–1951

The Eiffel Tower Seen through Tree Branches, undated

Lithograph on paper, 8¾ × 10⁷/₁₆

Jane Voorhees Zimmerli Art Museum, Rutgers, The State University of New Jersey, Gift of Frederick Mezey, 1997.0261

MANUEL ROBBE

France, active 19th century

La Visiteuse (The Visitor), undated

Aquatint on paper, image: 8⅛ × 5⅞, sheet: 12 × 8⅝

Fine Arts Museums of San Francisco, Achenbach Foundation for Graphic Arts, 1963.30.11479

THÉO VAN RYSSELBERGHE

Belgium, 1862–1926

La Régate (The Regatta), 1892

Oil on canvas with painted wood liner, 23⅞ × 31¾

Scott M. Black Collection

GEORGES SEURAT

France, 1859–1891

Study for "Le Chahut," 1889

Oil on canvas, 21⅞ × 18⅜

Albright-Knox Art Gallery, Buffalo, New York, General Purchase Funds, 1943

ALFRED SISLEY

France, 1839–1899

Moret-sur-le-Loing, 1888

Oil on canvas, 15⅛ × 22⅛

The Joan Whitney Payson Collection at the Portland Museum of Art, Maine, Promised and partial gift of John Whitney Payson, 15.1991.9

THÉOPHILE-ALEXANDRE STEINLEN

Switzerland, 1859–1923

Les Blanchisseuses reportant l'ouvrage (Washerwomen Carrying Back Their Work), 1898

Etching and aquatint printed in five colors on heavy white wove paper, plate: 14½ × 10⅝, sheet: 19¹³/₁₆ × 12¹³/₁₆

Smith College Museum of Art, Northampton, Massachusetts, gift of Selma Erving, class of 1927, SC 1976: 18-68

THÉOPHILE-ALEXANDRE STEINLEN
Switzerland, 1859–1923
La Comète (*The Comet*), undated
Lithograph on chine appliqué paper, image: 9³/₁₆ × 6½, sheet: 13½ × 10¹⁵/₁₆
Smith College Museum of Art, Northampton, Massachusetts, Gift of Selma
Erving, class of 1927, SC 1976: 18-69

THÉOPHILE-ALEXANDRE STEINLEN
Switzerland, 1859–1923
Rue Caulaincourt, undated
Lithograph on paper, image: 10 × 14, sheet: 11 × 14½
Fine Arts Museums of San Francisco, Achenbach Foundation for Graphic Arts,
1963.30.33785

ALFRED STEVENS
Belgium, 1823–1906
Sarah Bernhardt in Her Studio, circa 1890
Oil on canvas, 32⅛ × 25¾
Birmingham Museum of Art, Alabama, Gift from the Estate of Mr. and Mrs.
William Hansell Hulsey, 2000.160

JAMES-JACQUES-JOSEPH TISSOT
France, 1836–1902
L'Ambitieuse (*Political Woman*), also known as *The Reception*, circa 1883–85
Oil on canvas, 56 × 40
Albright-Knox Art Gallery, Buffalo, New York, Gift of William M. Chase,
1909

JAMES-JACQUES-JOSEPH TISSOT
France, 1836–1902
The Artists' Wives, 1885
Oil on canvas, 57½ × 40
Chrysler Museum of Art, Norfolk, Virginia, Gift of Walter P. Chrysler, Jr., and
The Grandy Fund, Landmark Communications Fund, and "An Affair to
Remember" 1982, 81.153

JAMES-JACQUES-JOSEPH TISSOT
France, 1836–1902
Women of Paris: The Circus Lover, 1885
Oil on canvas, 58 × 40
Museum of Fine Arts, Boston, Juliana Cheney Edwards Collection, 58.45

HENRI DE TOULOUSE-LAUTREC

France, 1864–1901

Le Comte Alphonse de Toulouse-Lautrec (Count de Toulouse-Lautrec on Horseback), 1883

Oil on canvas, 36¾ × 25¾

Mead Art Museum, Amherst College, Amherst, Massachusetts, gift of Harold F. Johnson, Class of 1918, AC 1953.64

HENRI DE TOULOUSE-LAUTREC

France, 1864–1901

Ambassadeurs: Aristide Bruant in His Cabaret, circa 1890

Lithograph on paper, sight: 53 × 37

Scott M. Black Collection

HENRI DE TOULOUSE-LAUTREC

France, 1864–1901

L'Artisan moderne, circa 1890

Lithograph on paper, sight: 34½ × 24½

Scott M. Black Collection

HENRI DE TOULOUSE-LAUTREC

France, 1864–1901

Deux Femmes faisant leur lit (Two Women Making Their Bed), 1891

Oil on board, 23⅝ x 31¼

Scott M. Black Collection

HENRI DE TOULOUSE-LAUTREC

France, 1864–1901

La Revue blanche, circa 1890

Lithograph on paper, sight: 51 × 36

Scott M. Black Collection

HENRI DE TOULOUSE-LAUTREC

France, 1864–1901

Troupe de Mlle Églantine, circa 1890

Lithograph on paper, sight: 24 × 31¾

Scott M. Black Collection

HENRI DE TOULOUSE-LAUTREC

France, 1864–1901

Divan japonais, 1893

Lithograph on paper, 31½ × 23½

Scott M. Black Collection

HENRI DE TOULOUSE-LAUTREC

France, 1864–1901

Jane Avril from *Le Café Concert*, circa 1893

Brush and splatter lithograph on beige wove paper, image: 10½ × 8¼, sheet: 17^{1}/₁₆ × 12½

Smith College Museum of Art, Northampton, Massachusetts, gift of Priscilla Paine Van der Poel, class of 1928, SC 1977: 32-232

HENRI DE TOULOUSE-LAUTREC

France, 1864–1901

Babylone d'Allemagne, 1894

Lithograph on paper, 49 × 33

Scott M. Black Collection

HENRI DE TOULOUSE-LAUTREC

France, 1864–1901

May Milton, 1895

Lithograph on paper, 31 × 23½

Scott M. Black Collection

HENRI DE TOULOUSE-LAUTREC

France, 1864–1901

La Chaîne Simpson (The Simpson Chain), 1896

Lithograph on paper, 33 × 47

Scott M. Black Collection

HENRI DE TOULOUSE-LAUTREC

France, 1864–1901

Jane Avril, 1899

Brush lithograph in four colors on wove paper, 22^{1}/₁₆ × 14^{3}/₁₆

San Diego Museum of Art, Gift of the Baldwin M. Baldwin Foundation, 1987:103

HENRI DE TOULOUSE-LAUTREC

France, 1864–1901

Repos pendant le bal masqué (*Respite from the Masked Ball*), circa 1899

Oil and gouache on cardboard, 22½ × 15¹³⁄₁₆

Denver Art Museum, Gift of T. Edward and Tullah Hanley Collection, 1974.359

ABEL TRUCHET

France, 1857–1919

Luxembourg Gardens, circa 1900

Lithograph on paper, 24¼ × 33⅞

Jane Voorhees Zimmerli Art Museum, Rutgers, The State University of New Jersey, Gift of Mr. and Mrs. Herbert Littman, 1986.1214

JACQUES VILLON

France, 1875–1963

Le Grillon, American Bar (*The Cricket, American Bar*), 1899

Lithograph on paper, 49¾ × 34⅝

The Museum of Modern Art, New York, Abby Aldrich Rockefeller Fund, 246.51

ÉDOUARD VUILLARD

France, 1868–1940

Le Jardin des Tuileries (*The Tuileries Garden*), 1896

Lithograph printed in four colors on wove paper, image: 11⅜ × 17, sheet: 16 × 22⅝

Smith College Museum of Art, Northampton, Massachusetts, gift of Selma Erving, class of 1927, SC 1978: 1-53

ÉDOUARD VUILLARD

France, 1868–1940

Jeux d'enfants (*Children Playing*), 1897

Lithograph printed in four colors on wove paper, image: 12¼ × 17½, sheet: 16¾ × 21⁹⁄₁₆

Smith College Museum of Art, Northampton, Massachusetts, gift of Selma Erving, class of 1927, SC 1978: 1-54

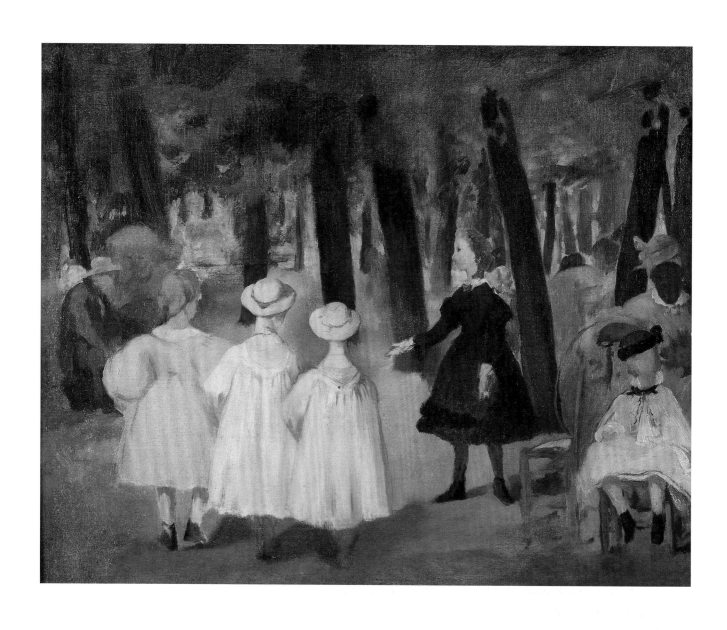

73. ÉDOUARD MANET

Children in the Tuileries Gardens, circa 1861–62

Oil on canvas, 15 × 18¼

Museum of Art, Rhode Island School of Design,
Providence, Museum Appropriation, 42.190

Lenders to the Exhibition

Albright-Knox Art Gallery, Buffalo, New York

Allen Memorial Art Museum, Oberlin College, Ohio

Gail and Tremaine Arkley

The Art Institute of Chicago

Birmingham Museum of Art, Alabama

Herbert Black

Scott M. Black Collection

Carnegie Museum of Art, Pittsburgh

Chrysler Museum of Art, Norfolk, Virginia

Currier Museum of Art, Manchester, New Hampshire

Denver Art Museum

Fine Arts Museums of San Francisco

The Haggin Museum, Stockton, California

Mead Art Museum, Amherst College, Amherst, Massachusetts

The Metropolitan Museum of Art, New York

The Montreal Museum of Fine Arts

Museum of Art, Rhode Island School of Design, Providence

Museum of Fine Arts, Boston

The Museum of Modern Art, New York

National Gallery of Art, Washington, D.C.

Joan Whitney Payson Collection

Private collections

Reading Public Museum, Reading, Pennsylvania

San Diego Museum of Art

Smith College Museum of Art, Northampton, Massachusetts

Toledo Museum of Art

Utah Museum of Fine Arts, University of Utah, Salt Lake City

Jane Voorhees Zimmerli Art Museum, Rutgers,
 The State University of New Jersey

Photography Credits

Jack Abraham: pages 5, 7, 10, 15, 29, 36

Photograph ©The Art Institute of Chicago: pages 47 and 79

© 2006 Artists Rights Society (ARS), New York/ADAGP, Paris: pages vi, 3, 36, 37, 105, 106, 108, and 110

Laurent Sully Jaulmes/Musée de la Publicité, Paris. All rights reserved: page 1

Erich Lessing/Art Resource, NY: page 28

Benjamin Magro: pages vi and 106

Melville D. McLean: pages ii, iii, 49, 54, 62, 84, 95, 97, 102, and 105

Photograph ©1990 The Metropolitan Museum of Art, New York: pages xvi and 56

Photograph ©1998 The Metropolitan Museum of Art: page 103

Meyersphoto.com: pages x, 21, 24–26, 50, 52, 77, 83, 87, 89, and 94

The Montreal Museum of Fine Arts, Denis Farley: page 98

©Musée des Arts Décoratifs, Paris, France/The Bridgeman Art Library: page 30

©Musée Marmottan, Paris, France/Giraudon/The Bridgeman Art Library: page 67

Photograph ©2006 Museum of Fine Arts, Boston: pages 32, 38, and 110

Digital image ©The Museum of Modern Art/Licensed by SCALA Art Resource, NY: pages 20 and 108

Image ©2005 Board of Trustees, National Gallery of Art, Washington: page 6

Image ©2006 Board of Trustees, National Gallery of Art, Washington: page 85

Sean Pathasema: page 92

Réunion des Musées Nationaux/Art Resource, NY. Louvre, Paris, France/ H. Lewandowski: page 69

Scala/Art Resource, NY: page 16

Courtesy of Sotheby's: page 81

Richard Stoner: page 99

This catalogue was produced in conjunction with the exhibition *Paris and the Countryside: Modern Life in Late-19th-Century France*, which was organized by the Portland Museum of Art and presented June 23 through October 15, 2006.

Edited by Fronia W. Simpson
Designed by David Skolkin/Skolkin+Chickey, Santa Fe
Printed by The Stinehour Press
Published by the Portland Museum of Art,
Seven Congress Square, Portland, ME 04101

Distributed by the University of Washington Press,
P.O. Box 50096, Seattle, WA 98145-5096
www.washington.edu/uwpress

COVER:
ARMAND GUILLAUMIN
France, 1841–1927
Detail of *La Plaine de Bagneux, au sud de Paris* (*The Plain of Bagneux, South of Paris*), 1874
Oil on canvas, 25¼ × 30
Private collection. Courtesy of Wildenstein & Co., Inc., New York

ILLUSTRATION DETAILS:
p. i, Fig. 12; p. ii, Fig. 61; p. iii, Fig. 37; p. vi, Fig. 68; p. x, Fig. 20; p. xii, Fig. 58; p. xvi, Fig. 42; p. 62, Fig. 65

Caption dimensions are in inches, height preceding width.